Life
Drawing
on the
iPad

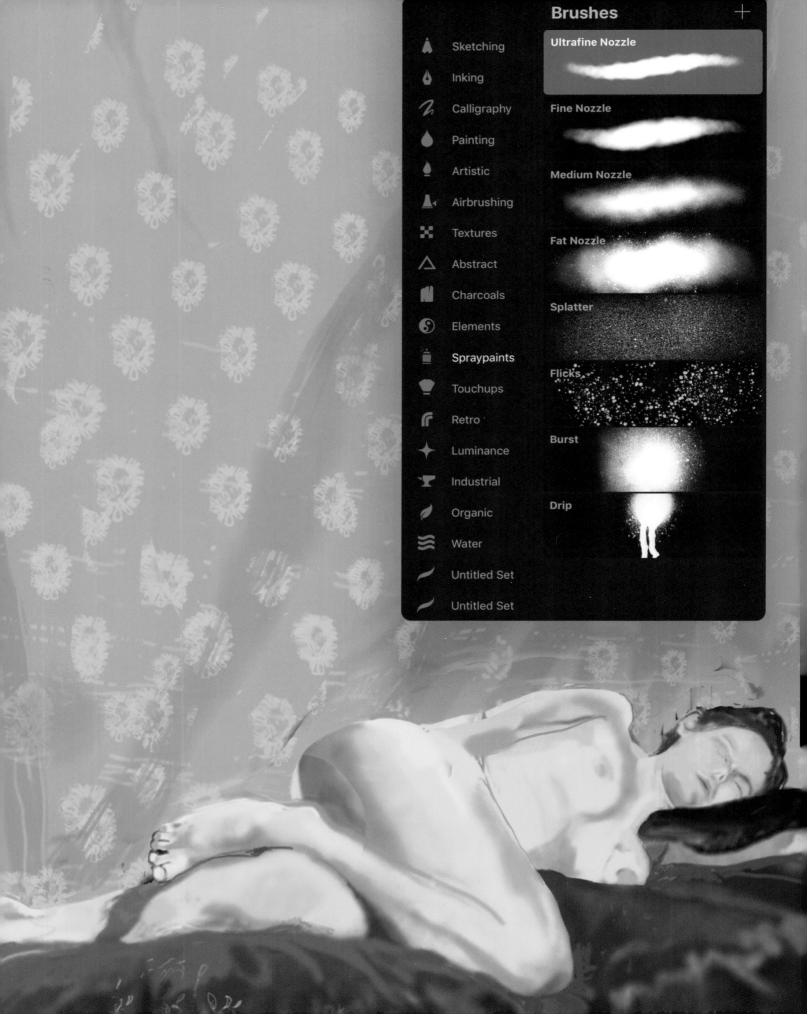

Brushes

Sketching	**Ultrafine Nozzle**
Inking	
Calligraphy	**Fine Nozzle**
Painting	
Artistic	**Medium Nozzle**
Airbrushing	
Textures	
Abstract	**Fat Nozzle**
Charcoals	
Elements	**Splatter**
Spraypaints	
Touchups	**Flicks**
Retro	
Luminance	**Burst**
Industrial	
Organic	**Drip**
Water	
Untitled Set	
Untitled Set	

Life Drawing
on the
iPad

Julian Vilarrubi

THE CROWOOD PRESS

First published in 2018 by
The Crowood Press Ltd
Ramsbury, Marlborough
Wiltshire SN8 2HR

www.crowood.com

British Library Cataloguing-in-Publication Data
A catalogue record for this book is available from the British Library.

ISBN 978 1 78500 417 9

This book is dedicated to my father, Josep Vilarrubí Sabaté, International Textile Designer

Acknowledgements

Thank you to artist and teacher Philip Tyler for proposing me to the publishers as the writer of this book. I am grateful to Phil for the enthusiastic chats and the enlightenment he willingly shares and passionately brings to something so close to us both: the craft and activity of painting and drawing.

Life drawing has been a constant through my art school years and beyond. At the Royal Academy Schools, thanks go to the life drawing tutors during my time there, Norman Blamey and Mike Biddulph. Norman was a specialist in the slow, meticulous response, considering structure, one passage against another and rendering transitions very carefully. Mike was the opposite, the quick look, assimilating the moment, tapping energy with verve and excitement from the quicker pose, pushing and cajoling us to get it down on the paper. These lessons left an impression on me.

Brighton has great life models. Since 1997 I have worked with most of them. Some appear in this book and I'd like to thank them for their dedication and professionalism.

All images in this book, unless otherwise stated, have been produced by Julian Vilarrubi using an Apple iPad Pro 12.9-inch display (1st generation) and an iPencil. Most of the drawings were made in Brighton with Brighton-based models. The models were, by page number: cover: Beatrice; 6 Sirona; 10 Dave; 14 Caroline, unknown model, Asami; 17 Vicky; 19 Katie; 22, 23 unknown model; 26 Marissa; 27 Asami; 30, 31 Lucy; 32, 33 Ariane; 34, 35 Kitty; 38, 40, 41, 42 Asami; 43, 44 Jennifer; 45–51, 53–55 Asami; 56 unknown model; 60 Rosy; 62 Marissa; 62 unknown; 63 Dave, unknown model; 66 Lindsey; 67 unknown model; 68 Frankie; 69 Lindsey, unknown model; 74 Asami; 75 Kate; 76 unknown model, Carole; 77 Marissa; 83 Asami, Rosy; 84 unknown models RA Schools; 85 unknown models RA Schools, Asami, Ariane, Dave; 86 Asami; 88 unknown model, Mark; 89 Naomi, Johanna; 90 Frankie; 93 Rosy, John, unknown model; 94 Asami; 96, 97 unknown model; 98 Lindsey; 99 Amy, Ian; 100 Karen; 102 Beatrice; 103 unknown model; 105 unknown, Beatrice; 106 Frankie; 107 Beatrice, Jennifer; 112 Ariane; 114 Vicky; 116 Lindsey; 120 Beatrice

Graphic design and layout by Peggy & Co. Design Inc.
Printed and bound in India by Parksons Graphics

Contents

Painting

Dry Brush
Old Brush

Oriental
Brush

Introduction

The history of pictures begins in the caves and ends, at the moment, with an iPad. Who knows where it will go next? But one thing is certain, the pictorial problems will always be there – the difficulties of depicting the world in two dimensions are permanent. Meaning you never solve them.[1]

DAVID HOCKNEY

This book is primarily about introducing you to objective drawing from the figure using the iPad. The aim is to demonstrate to you a number of ideas that you can learn and exploit to your own will. It will be possible, given the range of the visual imagination and the opportunity offered by the iPad, to do this in many ways.

You will need a downloadable drawing 'app' or application to work with on your tablet. There are many to choose from and they are all inexpensive. The app I will principally focus on in this book is Procreate but I will, of course, be considering other apps and I will run through the common principal features that are essential to know. These major features across the apps will work more or less in the same way but their interface will be slightly different.

The book focuses on the iPad. Most of what you read here will still be applicable for use on other tablets. The Android system has many of the same apps that can be used on other tablet devices. The iPad has a great choice of drawing apps available for use.

The iPad was originally designed to be used with a finger. With the popularity of drawing apps the stylus has become a necessary tool. There are several to choose from, the qualities vary and, again, these will be covered in some detail.

My advice is to develop a feel for one of the apps and master a few of the principal ideas and approaches in order to get going. In conjunction with this, I will write about the basic approaches to making objective drawings from the figure. Hopefully by combining the two you will be able to construct an image on an iPad fairly quickly. Stick with it as it feels strange to be working on a sheet of glass at first. Do not be too experimental in the beginning or else you will get off-track. It is important to be rigorous with your looking and be objective. After building up some skills, start stretching out the possibilities. Develop a habit of trying out similar ideas in a different way, whether that's using a new brush, changing the colours, undertaking timed poses, multi-layering images or whatever presents itself at that moment. Plenty of options will tempt you.

Work from real life models if you can. A real person will make a huge difference. It is an authentic experience. People move, breathe, live and you will react in many ways. Ways that you cannot when working from secondary sources.

Go to a local life drawing session. There are many to choose from nowadays in most areas, either tutored or drop-in. Look for a session that provides a good variety of models of all ages and types, both male and female.

If you are within a group of people look around and see what others are doing and how they are responding to the figure, even if they are not working digitally. Avoid working from photos if possible or at least get used to working from both. Photos are flat and have no scale. Understand the limitations and benefits of each. The figure is real. It is not trapped in time. Poses are finite and so can put pressure on you to respond in ways you may not normally. Try to make your drawing communicate. The difference between your intention and your response is your unimagined result. This makes it exciting. Have an engagement with reality and so reveal yourself through your drawing.

In this room we all produce very different images, looking at the very same thing. That's not simply the difference in skill or dexterity or a learnt style, it is because the feelings that a nude induces are personal and singular: no two drawings will ever be remotely the same. It is an old truism that in the life room you don't draw the body in front of you, you draw the one inside you. It makes no difference if it's male or female, black or white, old or young: all life drawing is camouflaged, shape-shifting self-portraiture: the images of what we search for in life and culture, an empathy with the human condition and the spirit that makes us sparks of the divine.[2]

A.A. GILL

WHY IPAD?

To draw and paint and to do it well is difficult enough in any medium. To do it digitally? How can a mechanical object be bent to our will? Can we create a visual response on a tablet that has soul and feeling? Can we draw on a glass surface and hope for a meaningful result?

Well, yes. You can use anything to draw on almost any surface. That is not a problem in itself. It's the drawing combined with the medium that carries the message and that makes it either good or bad. That can be done on an iPad as well as any other surface.

It's certainly true that there is something about the physicality and simplicity of drawing that makes it undefeatable. With strips of charcoal or pens, basic tools in our hands, it has barely moved forward. Brushes, an iPad app, which I use all the time, is not essentially different. It is faster, brighter, more flexible, but in the end it is a stylus on a surface, and the drawing is just drawing. Personal, direct, drawing has not "advanced". It stands outside glib ideas of progress. And it can remind us of something we are sometimes in danger of forgetting.[3]

ANDREW MARR

Working with the iPad still requires commitment and the use of the traditional skills. Depicting what you see is the difficulty. As Hockney's quote reminds us the technology may have changed but we are confronted with the same visual problems to solve. However, the iPad does offer new opportunities in approach and whether that is significant remains to be seen.

I had never considered working digitally before I purchased an iPad. I knew Photoshop and similar software were remarkable tools for digitally editing images but they had never appealed to me. I think it was the ease of making endless variations of the same image that put me off. I prefer to commit to one image. Also, it was desktop based. I'm an artist who likes to move. I'm a mobile creative, always looking around the corner for the next opportunity for a painting or a drawing. That's why the iPad chimed with me. I carry it around with me every day. Apart from drawing it provides so many of the requirements of a working day. Many of the remarkable possibilities found in Photoshop are now mobile as most of the apps reflect those options. However, my own personal rule is to not create endless variations on a theme.

The convenience of working on an iPad means there are a number of things you can dispense with that you cannot whilst using traditional media. You do not need to understand how oil paint is layered thin over thick and how it dries. You do not need to be able to mix your colours on a palette, unless you are exploring visual colour mixing. You do not have to wait for anything to dry, thus saving time. You will never overwork the paper surface and so compromise it to the point of unworkability. If you love to record what you see, experiment, develop your ideas, explore materials, mix your media and see your work as a time-lapse animation the iPad is for you.

The iPad will challenge you but it will repay you with an infinite range of possibilities that can and will provoke new ideas possibly to be developed with more traditional media at a later stage. Your complete studio is now in your hands at your fingertips. Your spatial requirements have been reduced. Perhaps your overheads will be reduced as a result.

Your working surface is convenient and discreet. You can work where you want to work, more or less. It is a mobile device. Take your studio with you to places you would not normally go, at different times of the day. You can respond there and then, be spontaneous and take risks. No need to try to remember anything or look for basic materials and perhaps miss the moment as a result.

It is also a visual diary stored conveniently in one place, easily organized and accessible, providing you with the freedom to print, send and share your images. The iPad is your portable portfolio. Reveal your work and yourself with ease, without having to show your work in a gallery. Share your work and receive feedback from a wide audience, anytime, anywhere. Everything you might need is there. Celebrate change and innovation. Connect globally.

THE FIGURE AND DRAWING

The figure is the most identifiable subject in art. It is the model for studying structure, proportion, life and vitality. It expresses desire, love, passion, loneliness, anxiety. I think most people would like to be able to capture the figure in some way. The response itself may be in great detail or it could be merely the essence of the figure. Either way, something has been set down that we recognize and it hopefully exudes something we can identify with.

Drawing the figure is always enlightening because it offers and entails so much and it will be different to each of us as we are all unique. All figures are interesting as there is so much variety. There seems to be a strong compulsion to capture one another in paint or through drawing. Something within us wants to 'see us'. There is a desire to record an experience of ourselves and each other in some way. To understand more. To reflect something.

The context of figure drawing can be similar but it is never the same. The lighting may be altered, the pose, the setting, the person, of course. Combine that with technique and process and we can choose from an infinite number of possibilities too. It tests our perceptions. The challenges can become compulsive. We feel we are familiar with the form of the figure.

How much do we really see when we look? Naturally we know something. Looking at a drawing we can instinctively understand what is right and wrong with it. The drawing of it delivers problems. Try drawing a figure from memory or capturing a likeness of someone you know very well and have 'seen' many times. Have you 'seen' them well enough to draw them from memory?

What I have not drawn I have never really seen and… when I start drawing an ordinary thing I realize how extraordinary it is, sheer miracle.[4]
FREDERICK FRANCK

Drawing is a method of communication. It records an intention. We are drawing to show something. It provides information. To make a good drawing you will need to know what it is you want to draw. What does your drawing want to communicate about the figure? If it can do that then it is a good drawing as it does what it set out to do. There's a point to it. In order to do this, we need to define our intention. What do you need to draw to communicate the idea? To set that down we need to be able to see it. We may not need to depict everything presented to us in order to do that, as by being selective we can still communicate our ideas. In fact, drawing is about selection and editing information, omitting elements that are not essential to the success of the drawing. If you show too much information you may say nothing. Drawing cannot record like a photograph. It is a record of an experience and unfolds through time. We can recognize something within it and we respond to that.

With the experience of drawing we can develop our ideas and create new work. It extends our imagination as a result. In addition, by exploiting a range of materials and a variety of approaches and techniques we can explore similar aims but get different results, thus perpetuating the line of experience and subsequent possibility.

Whatever drawing does, it excites and reveals. The beauty of it is its unpredictability. As you move through the process you cannot predict a definite outcome. The twists, turns, discoveries, compromises and surprises along the way are the hook that makes us return and try again to imbue our material with an energy and life we can recognize and respond to.

The promise of happiness is felt in the act of creation but disappears towards the completion of the work. For it is then that the painter realises that it is only a picture he is painting. Until then he had almost dared to hope that the picture might spring to life[5]
LUCIAN FREUD

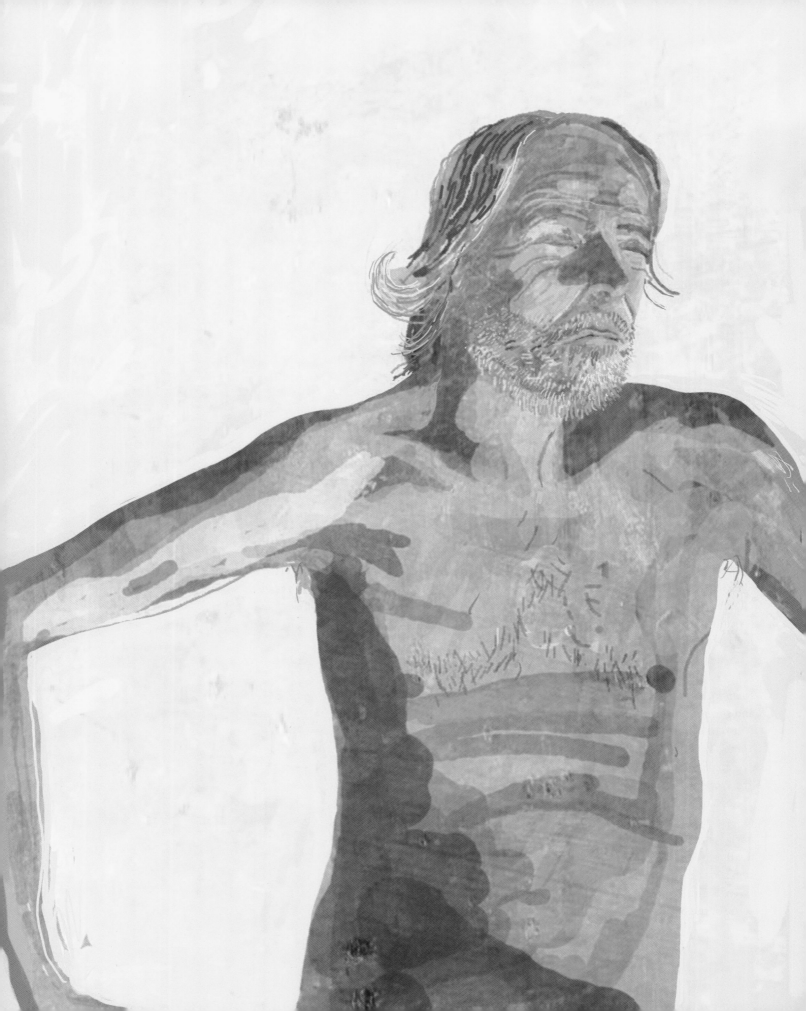

CHAPTER 1

Essentials

To draw and paint on the iPad you will have to download an app from the Apple App Store. Apple's mobile operating system is known as iOS. Different tablets have other systems available. All Apple iPads have the iOS operating system. Google's system is Android and Microsoft's is Windows. Each has its own app store and not all apps are available across the different stores.

There is a vast choice of apps. Some of the most popular ones are Procreate, Inspire Pro, Adobe Sketch, Adobe Draw, Sketchbook Pro, Paper by FiftyThree and Brushes Redux. The app most commonly referred to in this book will be Procreate. The other apps featured and mentioned will be Adobe Sketch, Brushes Redux and Auryn Ink.

Some apps become more established than others as a result of their quality and reliability. Apps are updated every so often, improving their functionality. Updating is quick and easy through the App Store.

It helps to try out a few of the apps to find a good fit. Some are easier to follow than others but they will all eventually make sense to you. It is a matter of perseverance. The more sophisticated apps offer more or less the same options presented in slightly different ways. Procreate is a top-of-the-range app used by professionals, yet it is easy to navigate. It has been optimized for use on the iPad Pro with the iPencil. You can still use Procreate on any iPad with any stylus, except the iPencil.

To use the apps effectively it will be helpful to understand some of the basic features listed here as essentials. These are the features that are the most commonly used and that differentiate digital drawing with an app from working on paper or canvas. The urge to get going is strong but with a basic understanding in place the results will be, hopefully, better, quicker and easier to accomplish.

There will be moments when you may wonder what relevance a particular approach or technique may have for you. By familiarizing yourself in advance with some idea of what is possible you will be able to adapt your approach accordingly, extending your process and ultimately your outcomes. The voyage of discovery as you navigate through the apps is a revelation. There are techniques and approaches to be discovered that will challenge your notions about making artworks and will make coming back to work with the iPad fresh and exciting each time.

CANVAS OPTIONS

To begin drawing and painting you will need to choose a surface to work on. As you open an app you will be given a number of options. Begin by pressing the + and selecting from the choices offered. This may differ slightly across apps but they will be more or less the same and will include preset canvas sizes for speed and simplicity. Orientation, shape and resolution will be the main options. When you select an image size, the number of pixels may vary between one size and another and that could determine the

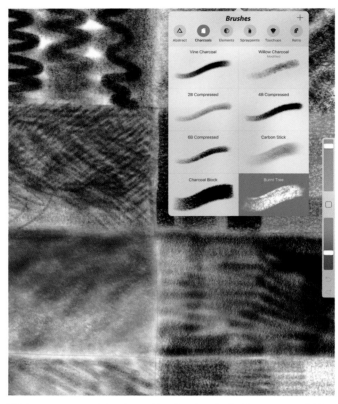

This is a screenshot of the charcoal brush palette in the Procreate app. Within each palette there are eight choices. Burnt Tree has been selected and is in blue highlight. The screen image has been drawn using some of the charcoal styles.

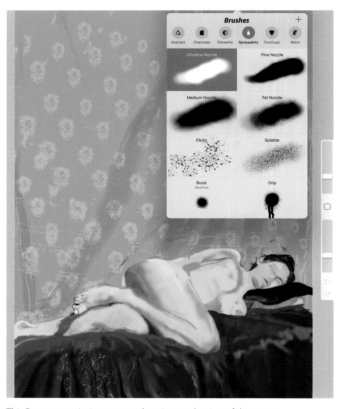

This Procreate painting was made using a selection of the spray paints brushes.

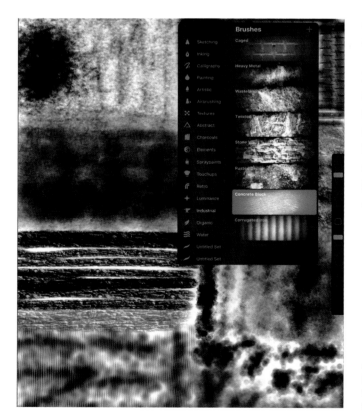

Another Procreate screenshot shows a selection of brushes from the industrial selection. Concrete Block is the active brush.

detail available for the drawing depending on the kind of drawing being made.

In Procreate there are a number of options to consider. It is possible to customize the size by setting the height and width and the DPI. The size of the canvas may have a bearing on the number of layers available for drawing on. The larger the size the fewer the layers available. To begin, choose one of the options available before you start customizing. If you plan to print out your work and are in doubt as to which canvas size to choose select a large canvas size.

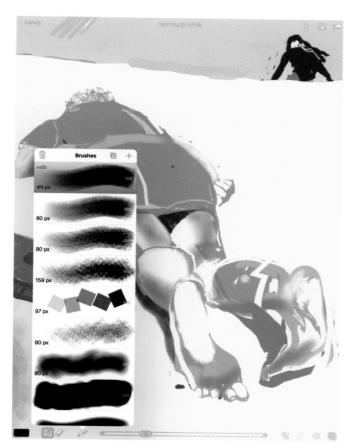

These are some of the brush options available with the Brushes Redux app.

The background image in this screenshot of the Adobe Sketch app was made using the Watercolor Flat Brush which is selected in blue.

An Auryn Ink screenshot showing the different brush options. Brush tips and sizes can be adjusted.

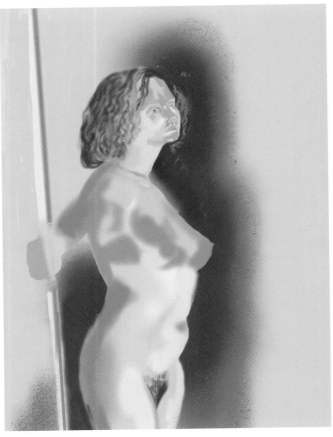

This image was created using Procreate spray-paint brushes in conjunction with a sharp eraser to maintain clear edges.

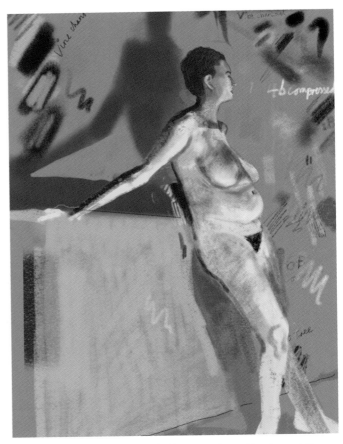

A drawing using a selection from the Procreate charcoal brushes palette.

BRUSHES AND EFFECTS

Brushes for painting and drawing are found in the brushes option of the apps. This is usually a brush symbol. Whether the brush styles are imitating wet or dry media or another less familiar style they are still all known as brushes. There should be a good range of brush styles available. From their names some will sound familiar and others will sound very unfamiliar. The more obvious choices will include brushes that imitate how traditional drawing and painting media might work. For example, in Procreate, there are options for charcoal, inking, sketching, oil paint, acrylic and spray paints. It is fairly easy to imagine what kind of marks might be made with these. There are other options that might not be so easy to interpret. Examples of these in Procreate

Using the Adobe Sketch app this painting has been made using the heavy acrylic brush. The brushstroke attempts to simulate impasto paint and could be likened to the look of oil paint as well as thick acrylic. Notice how the stroke appears streaky, suggesting variation in the thicknesses of paint as the stroke is laid in. As a result, there is a suggestion of light striking this uneven surface.

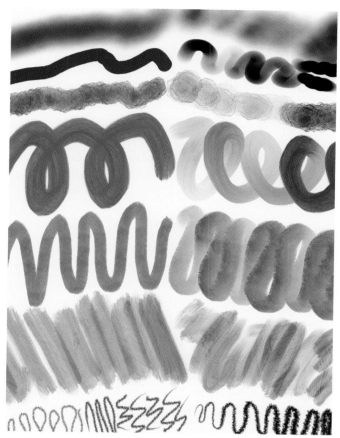

Further experiments in mark-making using the iPencil. Testing the linear possibilities of the Bamboo brush from the organic brush set.

On the left side are seven different examples of Procreate brushes using a basic stylus. On the right the same seven brushes have been drawn with the iPencil. Notice the differences. The iPencil is capable of making the same mark but can alter the width and tone depending on the pressure applied. This gives a truer, more life-like experience of painting and drawing. From the top, the brush styles are: Medium Nozzle from the spray-paints palette, Hard Airbrush from airbrushing; Fresco, Acrylic, Gouache and Watercolor from artistic, and Ink Bleed from inking.

might be abstract, elements, touch up, retro, industrial, organic and water. The challenge for you is to discover how you might eventually use and incorporate some of these into your work.

Within each brush category in Procreate there are eight variations or interpretations. For the 'charcoals' option you can choose from vine charcoal, willow charcoal, 2B compressed, 4B compressed, 6B compressed, carbon stick, charcoal black and burnt tree. They handle fairly convincingly like actual charcoal but with subtle differences between them. The choices within a less obvious category such as 'industrial' are heavy metal, caged, twisted tree, wasteland, stone wall, rusted decay, corrugated iron and concrete block. You can use as many brushes as you wish in a single painting or drawing.

All the choices in Procreate can be adjusted to your own specification. The settings allow you to take the basic mark and increase or decrease, amongst a selection, the streamline, jitter and spacing. You could even design your own mark-making tools by combining the two core elements, the shape and the grain. In Brushes Redux there is also a large selection of brushes that can be altered and added to in a similar way.

You can add brushes into Adobe Sketch by creating your own custom brush styles. Using Adobe Capture you can create a brush from your own captured image. This can be easily saved in Adobe Sketch as part of the Adobe Creative Cloud network.

TOOLS FOR DRAWING AND MARK-MAKING

Marks reflect the mark maker. They are imbued with information and they have a personality. A stroke can be exuberant, bold, confident and grand or faint, thin, nervous and timid. They can be made within a fraction of a second, exuding passion, movement, risk and energy or slowly communicating care, planning, focus and concern. If your stylus is capable of making such marks then you are well equipped.

In the early days of drawing and painting on the iPad you could use your finger on the screen or choose a basic stylus.

Options were limited. Drawing with the finger felt strange to begin with. We persisted in the hope that it could be mastered. It is possible to do great things with the finger. However, the width of the finger makes it difficult to see what we are drawing. That is as important for fine line work as the grander, wider strokes. Drawing can be about absolute precision and if you are unable to be precise because you cannot clearly see your mark then how successful can your drawing be? It is important to see as much as possible the point where the drawing and painting implement meet the surface. Also we are just not used to drawing with a finger. It can feel strange. We use tools for drawing and painting for a reason. That is what our hands, wrists, arms, eyes and body are used to working with.

There are a wide variety of styli available on the market. Some are extremely cheap and they do as good a job as some of the more expensive ones. The more expensive styli may look and feel better, come with a smart carrying case and be made of fine materials but they can still lack the capability of eliciting an essential ingredient in any drawing or painting: feel. If the mark is flat and uniform it may not be as expressive as is required.

A basic stylus can make the range of marks offered by the brush options in the app in a variety of widths and opacities and in some cases the tapering can be adjusted. However, often these changes are not instantaneous and they need to be adjusted individually. Drawing and painting with real tools does not work like that. It is a spontaneous act. The traditional tools we are used to offer variety and whether we exploit it or not the variety is inherent. You would have to try quite hard to make an expressionless brushstroke.

When using the finger or the basic stylus, the marks do not respond to differences in pressure. There is no response to pressure in the way that a brush or piece of charcoal responds as it runs dry of paint or wears down as it erodes. The marks record the twisting and turning of the hand. They can move from opaque to transparent and finally disappear. The finger cannot elicit such expression in variation. A Bluetooth-enabled stylus will give you many more options to explore these ideas.

The iPencil

The iPencil in particular has been developed to solve this issue. The iPad Pro and the pencil were designed to be used together. Unfortunately, earlier versions of the iPad will not support it as they are not pressure-sensitive. The iPencil will provide free-flowing painted gestures and can draw down to a single precise pixel. It appears to have no latency. If it has, it is imperceptible. It is regarded as the most sensitive and fastest stylus available. As it is Bluetooth-enabled, it is pressure sensitive and so works like a brush loaded with paint, a pen with ink or a piece of charcoal. When tilted, it can respond to the angle and create a wider stroke, so enabling shading. Within the pencil's case the pressure sensors measure how hard the tip is being pressed. The harder it is pressed the wider and darker the mark made and the lighter the pressure the more sensitive and lighter the mark.

Styli

The Sensu artist brush and stylus has a head at either end. One end houses the commonplace rubber tip and the other a micro-fibre brush to be used as a paintbrush. Using a brush tip certainly provides an enhanced experience of painting as opposed to using a stylus or harder pen-style tips. The brush itself feels soft and is responsive and dabbing marks onto the surface can simulate the sensation of using an actual brush. However, the Sensu brush is not Bluetooth-enabled and so is not pressure-sensitive. It may look and feel like a brush but it cannot act like one. The mark made on-screen will not vary its width and opacity in response. It also has, at times, a delayed reaction. This is not something you would want to experience in the act of drawing or painting. It does not reflect a real experience as such and will create hesitation. It is possible to alter the width of the mark and its opacity but this is done via the screen and app settings rather than naturally and spontaneously in the act of using the tool itself.

Adonit make a range of quality, great-looking and great-feeling styli. Their Pixel pen is Bluetooth-enabled, has palm rejection and is pressure-sensitive, and so has similar capabilities to the iPencil. The Adonit Jot Pro is a good basic stylus for writing and drawing. Another company with a number of stylish choices is Wacom.

Choose the stylus that fulfils the job you need it to perform. It may be that a rubber-tipped classic or a non-Bluetooth-enabled stylus can perform and provide you with the experience you require. If the line you need has to have a regular width and consistent opacity then a cheap stylus will suit this requirement. Variety in the mark, to a degree, can still be provided via the settings and sliders. Remember, some apps do not support every stylus so check in advance.

The Procreate circular colour palette.

The Procreate classic square colour palette.

COLOUR PALETTE

The iPad screen is backlit, making the marks glow. The brushstrokes will maintain their brightness and freshness over each other irrespective of what has gone before, below or above them. They are not wet, as in painting, and so do not bleed into one another. By using separate layers, the colours can be completely independent of each other, irrespective of their surroundings and yet still be a part of the painting. The colour can be applied opaque or transparent to create glazes, which can affect their tonality and hue. The great convenience of having layers enables the artist to try out a range of colour combinations and adjust as desired to achieve the effect wanted. This level of trial, error and correction would be impossible in traditional media. With some thought and planning layers can be worked out in advance and can be deleted, added to or shut down whilst easily adjusting their opacity, value, intensity, placement and scale.

Each app will have its own colour palette where you select the hue and have the ability to adjust a colour's properties. All the colours are to be found in the palette tool of the app. Colour mixing is made much easier as you make a selection of a colour rather than mix it from a combination as you would in conventional painting. It is not really necessary to know how to make an orange as you can see it and pick it directly. The decision would be which kind of orange is required, how intense should the colour be, would it lean to the yellow or red side and how light or dark should it be?

The palettes across the apps more or less follow the same format. In the following images, the colour palettes from five apps have been selected.

Procreate

Procreate offers a choice of two types of colour palette. One is a colour ring and the other is a classic colour picker. The outside of the circular coloured ring shows the range of hues and indicates the selected colour. The central circular section indicates the level of value and saturation of the selected colour.

The Brushes Redux colour wheel.

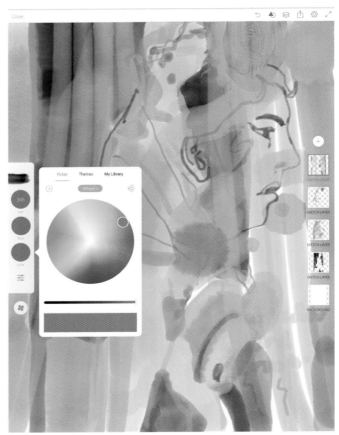

The Adobe Sketch colour palette.

The classic colour picker is square instead of round. Along the bottom there are three sliders for hue, saturation and value. As these are adjusted the cursor indicates this in the large square colour display.

Using the eyedropper facility, you can quickly duplicate any colour from the screen by tapping and holding. A coloured disk will appear under your finger. The top half of the disk is the selected colour and the bottom half is the previously used colour. Let go and the selected colour becomes the active one.

Sometimes it is helpful to have easy access to your colour history. Colours can be saved in the boxes just below the circular or square palette. Click on a box and the existing selected colour will appear in it. Colours can be saved either randomly or as a separate collection from a particular project. Storage palettes can be named.

A background layer can be filled with one even colour at a chosen opacity. Besides its colour, this layer cannot be adjusted and will only exist as the background layer so cannot be moved through the layers in relation to the others.

Brushes Redux

Brushes Redux has an RGB (red, green, blue) colour wheel. The slider under the wheel alters the opacity. In the colour box to the right you can adjust the intensity and value of the selected colour. Colour saving is possible within the palette. Tap one of the palette boxes and the active colour will appear in it.

To activate the eyedropper, tap any on-screen colour to make it the active colour.

There is no dedicated background layer in this app but the paint bucket will fill the whole surface of any layer. The selected layer opacity can be adjusted with the slider at the bottom of the layer window.

Adobe Sketch

The app opens with options on the left side. Click on the colour option and it will open up. There are three ways of accessing colour. The first is through the colour wheel where you can pick and adjust the colour you need. The second is through themes. The themes are pre-loaded palettes that you can select from. The third is by accessing the

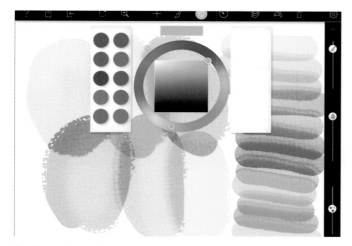

The Auryn colour palette.

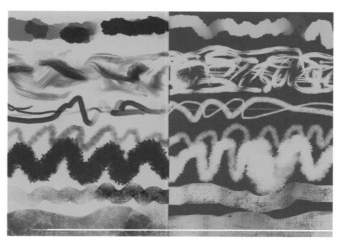

Positive and negative versions of the same marks. The negatives were made using the eraser in Procreate set each time to the same brush style as the positive mark. This allows you to bypass the standard one-style eraser and work more sensitively and creatively than previously. The brush style in this example is 'painting'. From top to bottom it is Round Brush, Old Brush, Flat Brush, Water Brush and Nikko Roll.

'My Library' option. Colours can be saved here by tapping the + icon on the upper left side of the colour wheel.

There are certain advantages to this app the others do not have. Adobe have a seamless range of apps available to artists and designers as part of their Creative Cloud series. Adobe Capture is one of these apps. With Adobe Capture you can turn any photo into a colour theme, a pattern, a vector graphic and as we have already seen, a unique brush. Working with the colour theme, you can create specific colour palettes for use in your paintings. The palettes can be sent to and stored on the Adobe Sketch colour wheel in the 'My Library' option. Conveniently, from there they can be selected for use in any drawing or painting within the app.

There is a colour picker with this app. Press and hold the colour circle in the tool menu and a colour picker will appear. Drag the picker over the required colour and it will load it.

Auryn Ink

Auryn Ink is an iOS watercolour painting app. It will simulate watercolour painting effects enabling wet on wet, wet on dry and glazing techniques. The colour picker shows the hue and colour name, the value or tone, intensity and brightness of the preview colour. You can create your own palette by selecting and dragging a colour to the rectangle to the right of the palette. Any on-screen colour can be selected by using the eyedropper. A long press and hold on the chosen colour will make it active.

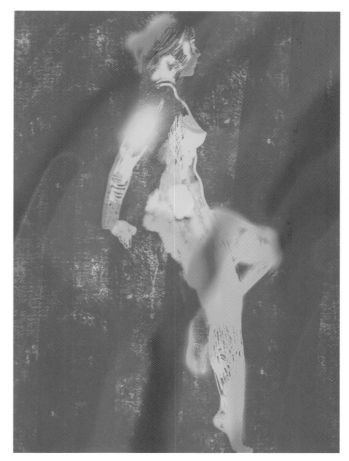

Erasing the figure out of a coloured layer, revealing the layer below.

Because Auryn Ink is a watercolour app, the lightness of a colour is dependent on the lightness of the surface below the painting as it would be with the traditional watercolour painting technique. Lightness of colour is not the result of adding white to the mixture as in true watercolour painting white paint is not used. For this reason, to control the value, regulate the amount of colour in conjunction with the dilution of 'water' in the mix. The more 'water' in the mix the more dilute the colour and so the more transparent and lighter it will appear.

ERASE

The eraser tool is in fact a very expressive and effective drawing implement in its own right. Think of it as a tool that makes marks in the negative. We tend to think of the eraser as an object that obliterates incorrect marks. This is true but the eraser can adjust marks and create marks itself thus being a tool potentially as expressive as any other. This can either be as part of the correction process or as a pre-planned mark-making strategy. The eraser in a charcoal drawing for instance will leave traces of its actions on the page as it is unable to totally remove the staining effects of the drawing material on the surface. These marks themselves can add effectively to the descriptive tonal drawing if exploited in the right way.

A special feature of the eraser in Procreate and Adobe Sketch is that it can be set to work in the exact same way as any of its brush styles. This adds another dimension to the subtraction of information. It simply makes a negative mark rather than a positive one. As with the brushes, it is possible to change its opacity and its size, thus giving a much more versatile and rich mark-making experience within the drawing. That means greater variety, subtlety and unity. The eraser is not only a tool to erase mistakes. It is a tool with which to draw and adjust the drawing. It should be viewed as a crucial part of the creative toolbox.

Erasing sections of the drawing will also provide the opportunity to reveal parts of the layers below, and so provide interaction between previously unseen parts of the drawing. This can lead to complex and unexpected juxtapositions of images. These effects would be very difficult to achieve or replicate in traditional drawing and painting media. The ease and speed of erasing, changing brush styles and the dramatic unplanned effect it can have make it a very exciting tool to work with. Remember, the eraser only works on the selected layer.

Brushes Redux is similar to Procreate. Its eraser can be selected to work in any of the brush styles.

Auryn Ink has a multi-strength eraser facility. In one way this provides greater control than is possible over the paper-based watercolour painting. Erasing watercolour effectively is almost impossible. The pigment, even when washed off thoroughly, will stain the paper fibres and leave at least some traces of its colour. In addition, the whole painting surface could become damaged and discoloured, so potentially ruining the painting itself. The eraser facility in the app provides an opportunity to work with 'watercolour' in a new way and keep the work fresh with fewer limitations. (It has to be said that the limitations of watercolour painting can be a part of its appeal and when successful can demonstrate planning and skill.)

UNDO/REDO

With a painting or drawing you adjust your work as you progress. This is its process. A series of corrections lead to a conclusion. This can be done on the iPad too. However, you now have the added advantage of being able to see all the previous marks if you need to. When painting on canvas or paper you are unable to go back in time to a particular place in the process or to correct yourself, although you could photograph your sequence, and record it that way.

Each individual action you make on the screen can be undone or redone in sequence. So, if you are making quick line drawings for instance and require a particular kind of mark you can attempt the same stroke many times until you are satisfied. This repeated attempt will have no effect on the surface of the painting or compromise what is below it. This could be seen as an advantage as well as a disadvantage. By using more than one layer you are protecting what you have already drawn and have total control over the final surface and its arrangement.

Remember that the undo only works in sequence and with limitations. It is not possible to undo the work to a particular point, adjust and re-lay all the subsequent marks that were made after that point. The correction effectively resets the painting to the chosen stage so all the previous drawing is kept but from that point on the work made will have to be made fresh.

Be aware that if you are revisiting a drawing that you have already worked on that has been saved and stored in the gallery section of the app it may not be possible to undo all the way back to the beginning of the drawing.

LAYERS

Layers are what make working with an app so interesting. Using layers is almost only possible digitally. They offer up so many options and variations. Familiarize yourself with what they can do and discover new exciting ways of building images.

Interpreting visual information into layers

We see and break down visual information into layers. We can divide, for the purposes of picture-making, what we see simply into a foreground, a middle-ground and background as three basic areas overlapping from the nearest to the farthest. By using the layers option in the app each can be worked on individually as a separate layer so when they are combined they overlap and make up the complete picture.

We experience and understand space because objects, people and things overlap as they exist within the space. A figure in the foreground will appear bigger and will clearly overlap part of what is in the background. Pictorially, beside overlapping, space can also be suggested in other ways such as through the use of perspective, changes in scale and atmospheric effects. In order to understand the layers option in the app we should acquaint ourselves with seeing some or all of the elements of the picture in separate layers. It is not always necessary or convenient to use more than one layer. You can use as many as you need, depending on how complicated your drawing will be, how you want to approach it, how you want to handle it and what eventually you want to do with it. It is still possible to work on a single layer as you would for a regular painting or drawing. However, using a number of layers will suddenly give you some options a single layer cannot.

When you draw or paint on paper or canvas you can only work on one layer. You have no choice as there *is* only one layer. You can still see, divide and approach the visual information in layers but the process of laying it down on the paper or canvas only allows one surface to work on. This means that any changes in the drawing or painting might completely or partially disappear as a natural part of that process. Some parts can be buried beneath the subsequent layers and other parts will be erased or rubbed away. This is a standard part of the process of making an image. There will generally be corrections or revisions as you develop and alter the work in order to arrive at a conclusion. What has gone before can be partially or totally invisible and no longer be a visual part of the work even though it may have been an integral part of its process. All the work exists on a single 'top' layer and embedded within it will be other inaccessible layers. That could be fine. The build-up of physical layers and the tactile qualities that might be a part of that are a significant part of the painting and drawing process. The lack of actual three-dimensional tactile qualities is one of the few drawbacks of working on a digital drawing.

However, using the layers options in the app will provide a new way of working and building images. It is like having many transparent sheets to work on which when placed on top of each other become one single image. They are a crucial part of the tablet drawing and painting experience as they will allow you to do incredible things you cannot do with regular painting and drawing.

What is a layer? A layer is exactly as it sounds. It is a transparent working surface. Each layer can be as large as the canvas size selected or the size of the part of the drawing existing within that layer. Whatever exists on a layer can be manipulated in several ways. Only one layer at a time can be active but you can see as many layers as you need. Each layer will act independently of all the others so any changes will not affect any other part of the overall work. One layer lies over the next layer and you can rearrange their order, reveal or hide any of them at any time. You can select a layer individually and adjust its opacity, distort and duplicate it, merge it, alter its colours or delete it. You can select and work on a background layer whilst maintaining the foreground undisturbed in front of it. It may be difficult to see what is going on as it will most likely be partially obscured but it is possible to do it.

Layers allow you to draw and erase certain parts of your drawing without destroying any of your work so far. You can turn off layers in order to focus on a particular layer without having the distraction of the others. The app opens up with one layer. It is not necessary to use more than a single layer in a drawing or a painting if you prefer not to.

Some apps have more layers available to you than others. In particular, Procreate has many layers available depending on the canvas choice. Brushes Redux has up to ten layers. Adobe Sketch has multiple image and sketch layers.

Auryn Ink has a different arrangement. There are three layers available, a wet, dry and fixed layer. These layers can interact whereas the layers in the other apps are stacked over each other. They cannot interact. What we see on-screen are all the layers that are open at that time.

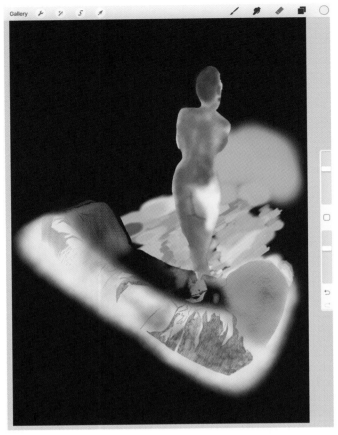

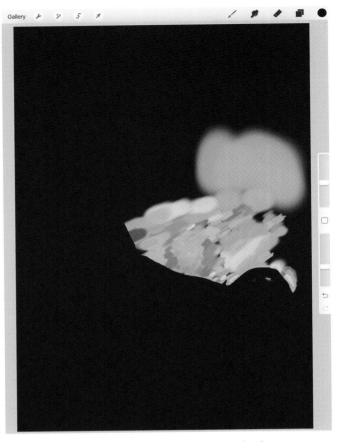

This painting is made up of three layers in Procreate with a dark flat coloured background layer. All the elements were drawn separately and later edited together. The parts were initially random and arranged like a collage, adjusting colour, scale and detail in order to arrive at a satisfactory composition.

This layer shows the blue space or surface moving into the distance.

MOVING AND HANDLING LAYERS AND IMAGES

The drawing surface is very receptive to being moved and adjusted. This is similar for many of the apps. In Procreate, two fingers on the screen will enable you to move the drawing around. Pinch it and it will reduce in size. Open the fingers out and it will enlarge. Open out to zoom in for detailed work and pinch in to see the whole composition. With two fingers on-screen, it is possible to rotate the canvas any way. This is useful as it means the drawing hand can work easily without contorting into a particularly tricky angle. Move the drawing image itself rather than having to rotate the whole iPad.

Three-layered drawing

Perhaps you are drawing the seated figure in strong light with a shadow falling behind, across the ground and up the wall behind. The drawing could easily be done on a single layer, of course. It could also be made on three separate layers. This would give you a level of freedom not available on the single layer. The background layer with the shadow would be the layer below that is overlapped by the other two. The chair and the floor could be drawn on the second layer. The figure, which is spatially nearer, would exist on the top layer.

Working on the separate layers gives you some benefits. It allows you to focus on details you may not have the same access to if you are working a single layer drawing. For instance, the shadow or whatever is on the back layer

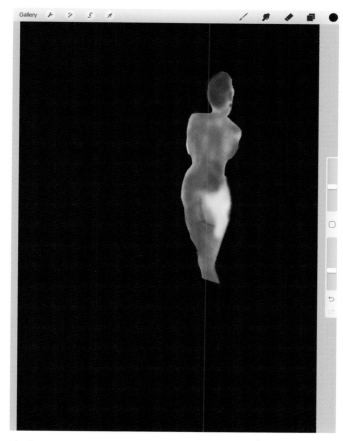

The figure on its own layer can be put anywhere at any size in the composition. This is also true of the other layers.

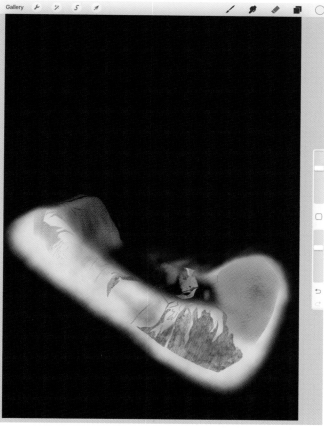

The couch shape has an off-white airbrush effect below it. Originally this was on its own layer behind the detail. These two layers were eventually pinched together to make one.

may need recolouring or adjusting in scale or detail. If it has its own layer this can be done easily and totally independently without it affecting the others. The transition of drawing through the back of the figure will also be smooth and consistent without any need to fill in awkward areas that may occur if the complete drawing is on a single layer. It can also be drawn at the last minute if needed whilst the other two layers are sitting above it, without disrupting any previous drawing. The shadow or detail will simply tuck in behind the other two layers. Editing and adjusting the edges of the figure or any part of a layer can also be done sharply and neatly if need be without compromising any other parts. On a single layer it is possible that the detail, added or erased, might interfere with other parts of the drawing.

Using layers to cope with complexity

The drawing of the skeleton uses fifteen layers. Layers work extremely well if you have complicated elements to organize in the drawing. By breaking down the information into sections it can be easier to focus on the areas, isolating them from each other to avoid confusion. During the drawing process they can be worked on individually or in combination. Eventually they will all be layered back together to show a complete drawing.

This drawing of the skeleton began with the shoulder blade. An area related to it and extending away became layer two. One section led onto the next, becoming a layer in its own right. You can pick and choose the layers, improving them in relation to each other as required, and going back and forth from one to another. This process gives you an added freedom not possible in conventional drawing. It means it is possible to start the drawing in a number of different places and not necessarily in the same scale. Simply call up the layer panel, tap and hold a layer

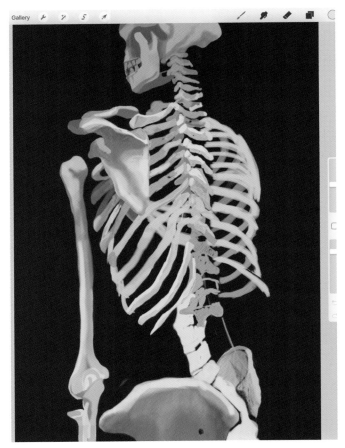

A Procreate screenshot of the skeleton. Because of the amount of detail and the size of the iPad Pro screen it felt comfortable to focus for this drawing on the ribcage, neck and skull only. The idea was to use the screen size just for these elements and establish those before considering the lower pelvis, leg bones and feet.

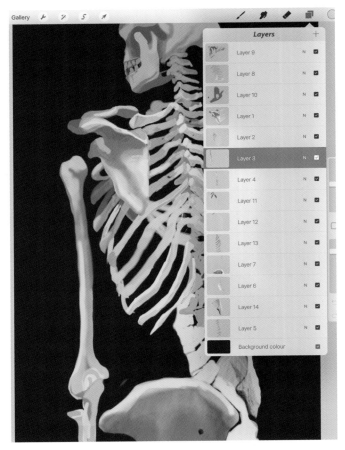

Another screenshot showing all the layers used in the construction of the drawing. Notice the highlighted layer in blue is layer one. This was the very first part of the drawing to be made, hence layer one. The layers are consecutive in number as they are requested but they do not need to remain in sequence. Layer one is not at the bottom of the layer ordering. Its position in the layer order was changed as the drawing developed. As it is, the shoulder blade is sitting over and obscuring other parts of the skeleton and so it takes its place in the order of layers where it demonstrates that overlap most effectively.

and slide to its new position. This can reveal or conceal new or older parts of the drawing. Later the layers can be arranged in any order and the different scales can be adjusted to match. By highlighting any layer, it is possible to adjust the scale of the drawing within it.

Remember that each layer has the potential to obscure some or all of the layer below it. On-screen they appear as one, as we see the layers over each other from above as one single image.

In Procreate, any of the layers can be pinched together in the layer panel at any moment to form one single layer. After a certain point of using and switching between layers it may be easier or more convenient to combine all or some of them into one.

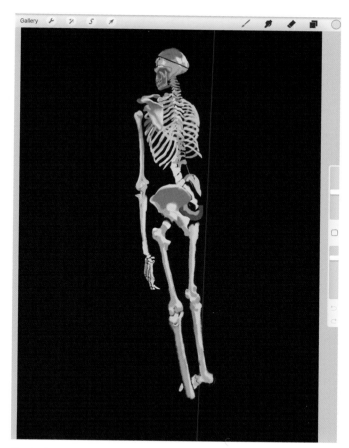

Here is the upper part of the skeleton joined with the lower sections.

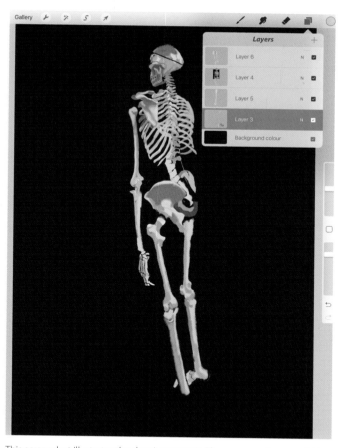

This screenshot illustrates the drawing process. The upper section was fairly well established so all the layers from the previous drawing were imported as a single image into a new drawing. This layer can be seen as layer four in the screenshot. Three more layers were added to describe the remaining sections of the skeleton. Layers one and two were either amalgamated into another layer or rejected for not being good enough and deleted as part of the drawing process.

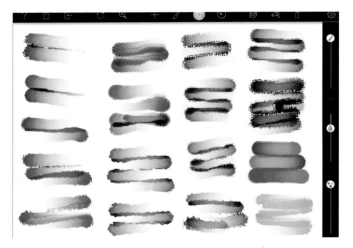

The Auryn Ink app has an option to change the paper's surface texture. The paper surface choice is an important part of the painting process and as such has a bearing on the handling of the material and the final result. Watercolour paper varies from a smooth to a textured finish. The pigment can collect in the textures of rougher paper giving the painting a particular look. The roughness of textured paper means it works well with a dry-brush effect. Auryn Ink provides a range of options to reflect paper surfaces. This screenshot is a random test of the brush options against the different paper surfaces. Notice how some brush marks have broken edges whilst others have a smoother, flatter finish.

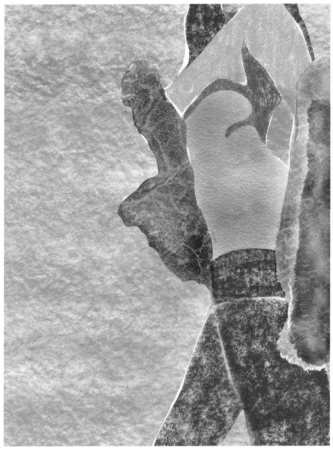

All the textures in this drawing derive from the brush choices as opposed to the paper or layer surface. Layers have no surface qualities themselves. They have the illusion of a surface texture when particular brushes are used. In this case, from Procreate, the drawing uses Artist's Crayon, 6B Pencil, Shading Graphite, Soft Pastel, Rough Skin and 6B Compressed.

Layers and surfaces

Building up surfaces in painting and drawing, either deliberately or as a product of the process of laying down material, can become an important part of the artwork, affecting how it is viewed. On the iPad the digital drawing has no surface quality even if the drawing or painting is layered over and over. It will not have a tactile presence. It can create the illusion of one, but the surface is the flatness and smoothness of the glass as it exists digitally. When the image is printed out any texture in the print comes from the paper surface and not the image, even if the image has created the illusion of texture.

ZOOMING AND PANNING AND REFERENCING SCALE

Our relationship to the drawing surface is extremely important. To draw well we need to have a good sense of the scale and orientation of the surface being used and feel confident in our ability to alter and change it easily should we need to during the process.

Zooming in and focusing on a small area of the drawing image is a necessary part of the experience. It happens often in painting and drawing. As the screen size of an iPad is limited, it might be necessary to zoom in in order to get into the detail of the drawing. This can be easily done on screen. The danger is that, if focus is lavished on a small section of the drawing that has been blown up to

There are two layers in this image. The wall texture on layer one is a photograph of brickwork. The figure is drawn and partially erased on layer two using brushes that have similar textural qualities to the wall.

THE BEHAVIOUR OF PAINT

When applied to a surface, whether it be paper, canvas or something else, paint has the potential to react in many ways. It can bleed into it, sink, pool, absorb, fade, disappear, discolour, wrinkle or even distort the surface support itself. That is one of the great attractions of using paint. It is not always easy to predict what might happen in the process of working and that leads to the unexpected. The results themselves, if they appeal, can be ripe for exploitation, and perhaps be channelled, controlled or cajoled to great effect or merely abandoned.

Painting on the iPad has something of the unpredictable about it too but not to the same extent as conventional painting. With many apps there is little choice as to the qualities of the painting surface. Some of the brushes have 'surface' qualities inbuilt with the stroke.

As in conventional painting, when using paint on the iPad, you have to be conscious of your process and remember the results of particular actions and hope you can recreate them.

full-screen dimensions, the scaling may be lost as the rest of the drawing is hidden. This would not really be a problem on paper or canvas as you can see the whole instantaneously even though the attention may be on a small section. It may be that for such a situation a reference layer may be useful. This will provide a template to follow to keep the proportions accurate.

A reference layer may have information on it that will help and guide you to make your drawing or painting. You can import images, either photographic or drawn, into a layer that is blank or has already been worked on to guide further work. Using an overlying layer, it is possible to trace over the reference material. Once used, the reference layer can be eradicated or hidden.

TACTILE QUALITIES

Paintings and drawings have surface qualities. A dark area of charcoal in a drawing has a particular physicality. It has a velvety richness caught by the texture of the paper surface which can at times appear as if it just barely sits on the surface and could, with a sudden gust of wind, simply slide away. Great artists understand surface qualities and some exploit them in their work as an essential part of the experience of the work itself. The actual physicality of the material can be a key component.

Well-known examples might include Rembrandt and Constable. More recent examples would be Anselm Kiefer or Francis Bacon. For a full-on visceral encounter with a Bacon painting it is necessary to get up-close and see the physicality of the paint and how it has been applied. That is a part of the excitement. Oil paint in particular has properties that transcend colour. It is a physical substance that can be used in that way. Besides colour and its attempts to depict something, the physicality of the paint itself responds to light and changing light conditions. Kiefer goes further in his use of material, actually at times attaching objects and three-dimensional material to the surface and treating the painting almost like sculpture.

All this will affect the surface of the drawing or, in particular, the painting and that will have an impact on the viewer's response. The material can be laid thickly and built up, scratched away at and layered. This can be achieved on the iPad too, but the image is a digital one and so has no physical presence as such. In fact, it does not really exist as more than a stored file. When printed the image will be completely flat and any surface qualities in the painting or drawing will be embedded within the flat surface of the paper, never having existed at all in the first place, only suggested at by the textural description in the drawing or the painting within the glass.

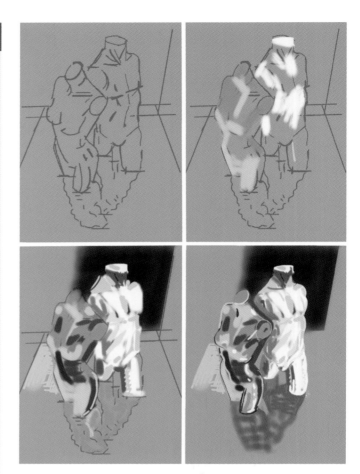

An underdrawing layer can be used as a reference guide for a painting or drawing. New layers are transparent so a single layer or a number of layers can be laid in above it and worked on. In this example, the underdrawing in red provides a template for the composition. As the painting develops the guide becomes overlaid by painted marks and can finally be deleted if required. The reference layer can be a photographic, painted or drawn image imported from the photo library.

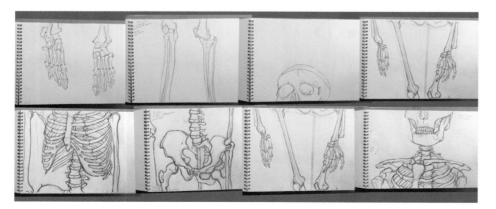

These A4 drawings were made from the skeleton in pencil, scanned and imported into eight Procreate layers.

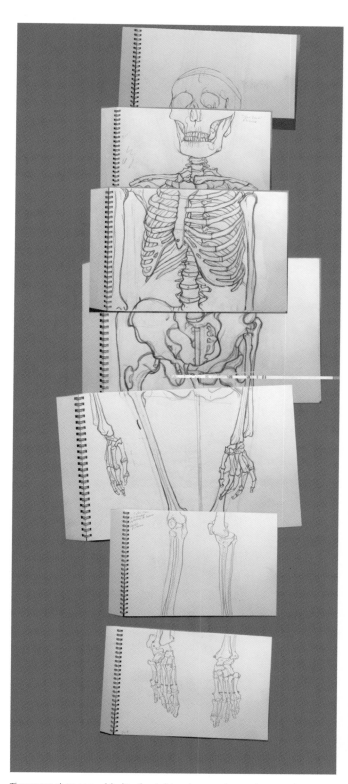

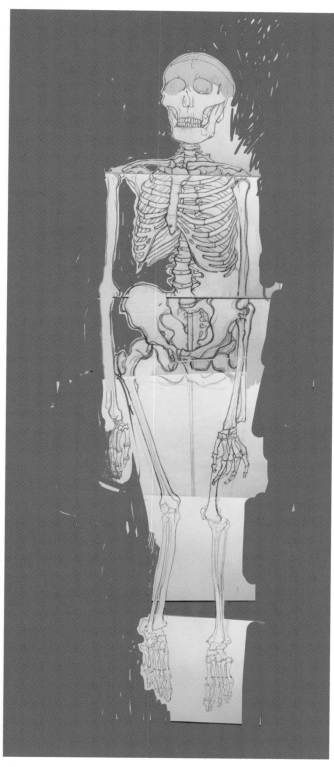

They were then assembled in the right order to make up the complete skeleton. All the layers were then pinched together to form one single layer.

The drawings now become one and so can be worked on as a digital version adding and cropping as required.

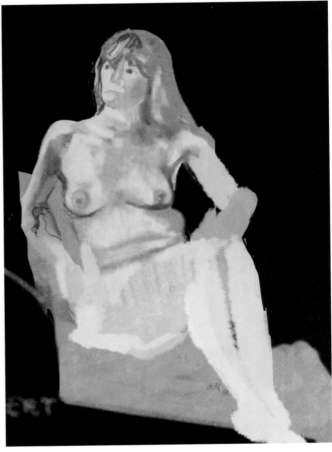

Try working out the composition of the painting in the process rather than pre-planning it. If proportional calculations or compositional considerations need to be changed it is possible to increase or decrease the size of the composition using the layer adjustment tool and the zoom feature. This drawing of the figure began off-centre to the right with the legs moving out of the frame.

The layer was highlighted and the figure was moved to the centre. This makes way for the legs and increases the space around the figure. The remaining parts of the legs were then added.

Finding a composition

I like to work on an unframed canvas that is larger than the intended picture. This gives me room for alteration. I find this method very agreeable[6]

PIERRE BONNARD

Having the ability to zoom in to the drawing and then if required adjust the scale of the layer itself in relation to the paper dimensions gives you great freedom. Some artists would prefer not to commit to a rigid compositional arrangement, allowing elements of the image to discover themselves in time. In a sense it is a digital equivalent of Pierre Bonnard's approach as described in his quote. There are few restrictions on the size of the image in relation to its edges. In the digital drawing the image itself can be enlarged or reduced as many times as necessary to get the right balance and scale of elements. In his paintings, Bonnard preferred not to decide in advance where his canvas edges would lie so he gave himself the potential to extend the edges by working on a piece of canvas unbound by the size constraints of a particular stretcher. He was a painter who found it easier to work on canvas pinned to the wall rather than to a set, specified shape and scale. This gave him freedom to work out his composition in the process of making the painting rather than having the restrictions of a predetermined dimension.

The iPad surface and the layers can be regarded in the same way, especially when using Procreate and Brushes Redux. The drawings and paintings have the potential to be scaled up, down, added to, enlarged and reduced using layer highlighting.

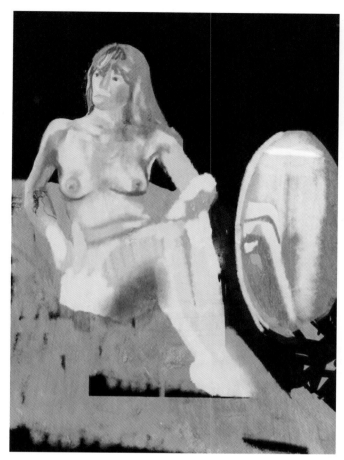

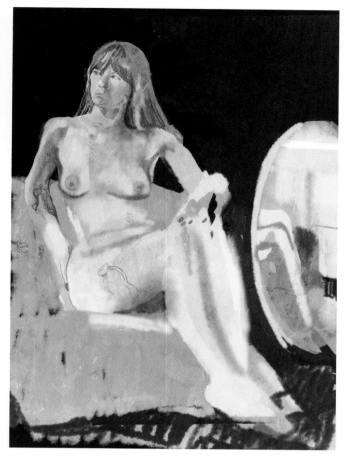

Her scale was reduced further and she was moved slightly to the left to make way for the mirror on the right-hand side. The mirror now counterbalances the figure in the composition.

Further small adjustments were made to the arrangement of the elements in the composition. Zooming in on the face and the hip allows finer details to be included now that the broad shape of the composition has been arrived at. The final image shows the drawing as it was left, in a fairly well-established, yet incomplete, state. Working on paper or canvas would have restricted this freedom to move the figure around.

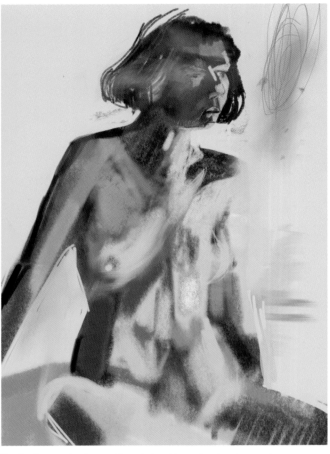

These three images illustrate how easy it is to change the background colour of the drawing. The image remains exactly the same.

The background colour and its relationship to the drawing can have a striking impact on the complete painting.

Using layers to move around the drawing and change the composition

When beginning a drawing on paper some planning and measuring is required in order to fit all the elements needed onto the sheet. Simple comparative measurements will be required to know how and where the figure will go. One of the great advantages of working on the iPad is that you can plan in the traditional way but you can also begin your drawing at almost any scale and size then by adjustment fit it to your drawing area.

The figure has a tendency to grow beyond the edges of a sheet of paper. This can happen on the iPad. The scaling can be altered in order to reconfigure the drawing's relationship to the four sides. We can reduce the scale of the drawing within the rectangle and move it around the space to add more drawing. This could also be reversed. This is an opportunity to experiment with composition and cropping and perhaps alter the feel of the drawing.

If the whole drawing exists on a single layer, this complete layer can be highlighted and adjusted in this way. Within the rectangle of its layer it can be increased, decreased in size, moved around, cropped and distorted. If the drawing is made of a number of layers, only one individual layer can be adjusted at a time.

Zoom into a layer to work in detail.

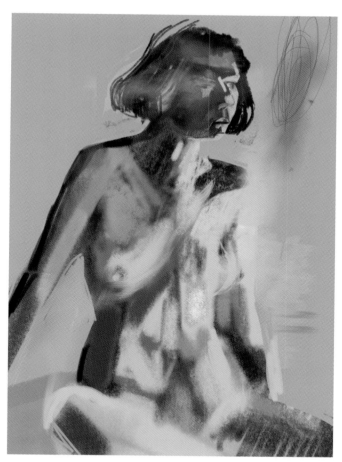

The drawing will respond to the colour and tone of the background layer.
Some parts will be enhanced and others diminished as a result.

In the top image, the head in the drawing is too small and needs enlarging to fit proportionally with the body. By using the select and transform tool the area to be enlarged can be highlighted. The area for enlargement is clearly visible in the lower drawing.

Once the area has been identified the layer selection tool can be engaged and this will highlight it. This can now be reduced, enlarged and moved into position as required.

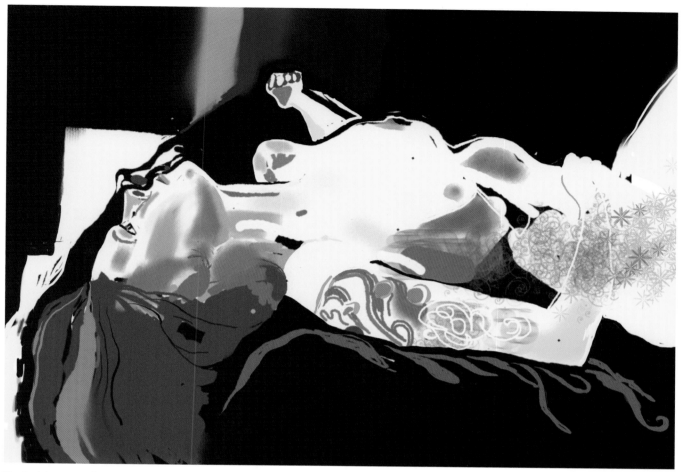

The final drawing with a larger head.

Background layer

In Procreate there is a layer known as the background layer. This will always be at the bottom of all the layers. It is only possible to alter its colour. The flat colour exists across the whole layer and nothing else can be added to it. It is possible that none of the background-layer colour, whatever it is, may be visible as it could be obscured by the layers above it. This background layer can be altered easily at any point in the drawing or painting process. It enables you to conveniently try out any colour and gauge its impact on the whole composition.

Select and transform tool

This Procreate tool is very useful. It allows you to select any area, large or small, from any layer of your drawing and adjust it. It may be that you need to move, reduce, flip, duplicate or enlarge it. For example, your figure drawing may be proportionally incorrect. The head may be too big for the body. By selecting just the head with the select tool it is possible to resize and then relocate it. Performing this action on paper would be impossible, unless you were making a collage. The selected area would have to be erased and redrawn. That would be fine in itself as adjustment is an important part of the drawing process but having the facility to do this on the iPad will save you time and perhaps frustration.

GALLERY

This is where all your work will be stored. Each app will have its own gallery space. When you open the apps, you will usually be presented with the gallery itself. From here you can choose what you would like to do, whether that is to continue working on an ongoing piece or choose a new canvas.

Kitty 2
1714 × 4096px

Kitty 1
1714 × 4096px

Industrial Brush
210 × 297mm

Kitty Reclining
3508 × 2480px

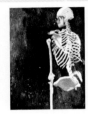

Skeleton 1
2480 × 3508px

Lucy 23.07.16
210 × 297mm

Stylus and IPencil
210 × 297mm

Skeleton
Group of 9

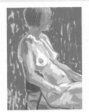

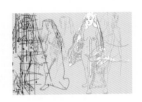
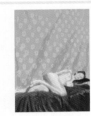

Untitled Artwork
210 × 297mm

Measured Drawing
Group of 56

Untitled Artwork
297 × 210mm

Untitled Artwork
210 × 297mm

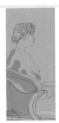
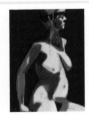

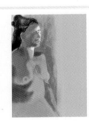

Untitled Artwork
1714 × 4096px

Dave
210 × 297mm

Untitled Artwork
210 × 297mm

Morgana
210 × 297mm

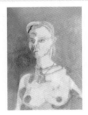
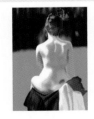

Jennifer
2480 × 3508px

Linds
210 × 297mm

Frankie
210 × 297mm

Bamboo and sable
297 × 210mm

Procreate images can be named and stored chronologically. They can also be reordered and arranged in groups in an individual folder. From here they can be sent out, shared, deleted or retrieved for further work.

The Brushes Redux gallery is more limited. When you open the app, you will see your stored images. They can be named. From here you can reopen to continue or choose the + symbol to select a new canvas.

Adobe Sketch images can also be grouped and named. Again, from here they can be selected, sent out or you can begin a new piece.

Auryn Ink opens onto a blank sheet of paper ready for painting. Select the gallery option to view the saved work.

Saving and sharing

The apps will save in their galleries the format the painting or drawing was created in. If you need to return to it, the work will be waiting ready to be continued. All the layer information will be saved in order for any further work to be carried out. From the gallery the images can be sent out.

You might want to send images to different locations for a number of reasons. Options across the apps will include saving to photos, sending through iMessage and email, or to cloud services and social media. The options can be adjusted.

Procreate offers a choice of file formats for sharing to suit different purposes. The PSD option will allow you to save and export all the information, layers, visibility and blending modes to Photoshop. If you save your image in Pro all the layer information will be kept intact also. Other options are saving as a JPEG, PNG and PDF. A JPEG will flatten the file into a single layer and a PNG will flatten with full quality. Saving in PDF is good for digital distribution and for sending to print houses and publishers.

Adobe Sketch has a number of options in addition to those described previously. Send your work directly to Photoshop and Illustrator for further development or share your images on the community gallery, Behance.

PLAYBACK

Some drawing apps have video playback. Procreate has this feature. The drawing process is recorded in time-lapse and you can watch it back. It is an interesting addition to the creative process that normally goes unseen. Every bold mark, subtle adjustment in placing and scale, hesitation and correction all go towards making the image and you can follow this though time. This can help you determine at which point you made key decisions and how you might develop in response. It is also great to see your drawing as an animation.

A screenshot of the Procreate gallery showing thumbnail images of paintings and drawings. They each have image dimension information and a title, if added, or if stacked in folders the number of images contained. In this image we can see a folder or a stack for measured drawing which contains fifty-eight images.

Measured Drawing

Observation lies at the heart of the art process. Whether your art derives from mimicking nature or extrapolating a mental construct, your powers of observation are critical. Unless you can see what lies before you, you cannot describe it. Train yourself to eliminate preconceptions and received understandings when observing anything. Try to see what is before you, not what you think or want to see.[7]

KIT WHITE

Making an accurate observational drawing of the figure requires patience and time focusing on the parts and all of their interconnected relationships in order to describe the convincing whole. Looking hard is what drawing forces you to do as it needs to make sense. Recently, at a large well-known London gallery, there was a rumpus at an exhibition when visitors were banned from drawing the exhibits. That is a serious contravention of the art of looking, and looking deeply is why many people go to exhibitions. Some people need to draw to see what they would normally miss. Dr Michael Glaser, director of Science at King's College London, explains that when you see something familiar the brain pieces the parts together to help you understand it. When the brain is satisfied with the information, it assumes we have 'seen' it. However, the familiar object has not really been 'seen' with depth and understanding. It is through the drawing process that 'seeing' well enough to describe something has to happen. It helps, especially with approaching measured drawing, to attempt to forget who or what you are drawing and look at it objectively as a series of relationships you are required to understand and set down clearly. There are several approaches to assist with this. One is to upturn the familiar object and draw it upside down in order to defuse any preconceptions about the visual relationships and to encourage a fresh response. That may prove difficult when working with a live model!

HUMAN PROPORTION

Artists have been preoccupied with the proportions of the human body since the Ancient Greeks. In particular, Leonardo da Vinci and Albrecht Dürer spent much of their time studying it. Leonardo was concerned with the idealized measurements for the human body whereas Dürer's approach was more realistic. Dürer was interested in reflecting the wide variety of shapes and sizes found across figures to illustrate their unique proportions and their beauty. He believed there were 'many forms of relative beauty…conditioned by the diversity of breeding, vocation and natural disposition'[8]. He encouraged artists away from idealized beauty and wrote a book in response to his ideas, *Four Books on Human Proportions*, published after his death in 1528.

The idealized body could be said to divide into seven and a half or eight head heights. Leonardo da Vinci's famous drawing, 'Vitruvian Man', of around 1490 is based on a text by Vitruvius the Roman architect and engineer of the first century AD. Vitruvius described the human figure as being the principal source of proportion among the classical orders of architecture.

Not many people, if any, have ideal proportions like the Vitruvian man and that is what makes observing the human figure so interesting. The differences and varieties of shape, size and colour make it fascinating. The ideal proportions were based on the standing figure and it is a useful yardstick in general. Using the head as a unit of measurement

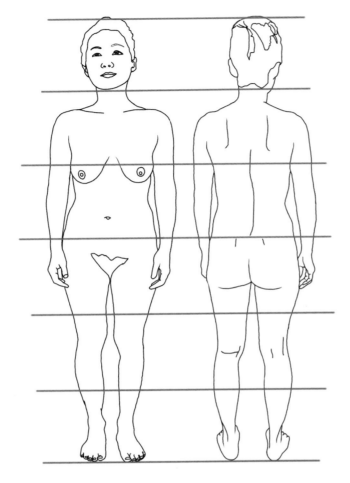

The same model has been used for the following series of measured drawings. This illustration shows the head height in comparison to the whole. She is six head-heights tall.

To draw the figure accurately you will need to understand comparative measuring. That is simply measuring by making comparisons. When we look at an object we can usually see that it might be taller than it is wide, for instance. We are measuring by eye. We might even be able to use our eye to determine the proportion between the width and the height. At some point the guesswork becomes inaccurate and a measuring method needs to be used to make it more rigorous.

The method outlined here can and should be adapted by you. It is a rigorous method designed to record accurately. The starting point of the head in this case is convenient because of the pose. All poses are different so starting points will change. It does not need to be the head. In this example, the pose is more vertical than horizontal so a vertical marking line is required. In a predominantly horizontal pose that would change to a horizontal marking line. The point of the measured drawing is to build, as much as possible, an accurate drawing. Not all drawings need to be as mechanical and as accurate as this. Drawings can be about other ideas, not just accuracy. However, the measured drawing principles can still be loosely referred to when you are drawing quick poses and time constraints are forcing you to make quick decisions.

The naked human body is the most familiar of mental images, but we only think we know it. Our everyday factual view is of the clothed body, and on those occasions when our dirty mind will strip a person, it will see something idealized. Only the mature artist who works from a model is capable of seeing the body for itself, only he has the opportunity for prolonged viewing. If he brings along his remembered anatomy lessons, his vision will be confused. What he actually sees is a fascinating kaleidoscope of forms: these forms, arranged in a particular position in space, constantly assume other dimensions, other contours, and reveal other surfaces with the breathing, twitching, muscular tensing and relaxation of the model, and with the slightest change in viewing position of the observer's eyes. Each movement changes as well the way the form is revealed by light: the shadows, reflections and local colours are in constant flux.[9]

PHILIP PEARLSTEIN

or ruler to determine other dimensions across the figure is a good starting point. Many poses are not set standing square on to the artist and so almost all poses disrupt the idea behind the ideal proportions. Depending on the point of view, the figure will seemingly alter itself and each time present a whole new set of drawing propositions. Add into any of these actions extreme foreshortening and you have an almost infinite array of possibilities and what might have previously been relative proportions in a standing figure have now been compromised and altered. Perhaps even the head itself might not be visible in some cases.

Figures do follow some general principles proportionally and some of these are determined by gender and age. There is a variation in body shapes. Young children's heads are proportionally larger to their bodies than adults' heads. Men tend to be more muscular than women, with wider shoulders and longer torsos. See the Anatomy section for more detail.

MAKING A MEASURED DRAWING USING LAYERS

Fit your parts into one another and build up your figure as a carpenter does a house. Everything must be constructed – built up of parts that make a unit: a tree like a human body like a cathedral.[10]

HENRI MATISSE

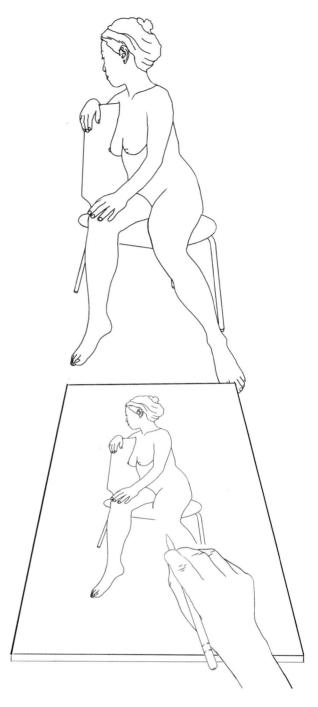

VIEWPOINT

Before beginning a measured drawing there are some important considerations to observe. You have to maintain a fixed viewpoint or else there may be discrepancies in your drawing through inaccurate measuring. Avoid this by being aware of your viewpoint and maintaining it throughout. Consider your unique viewpoint in relation to the model. Mark your position if necessary. It is difficult to retain accuracy if you are not facing the model as much as possible. If you are facing away from the model, the space between seeing and recording is greater than it needs to be. This means any information you carry between the model and the drawing has an increased chance of being inaccurate as you transfer your attention from one to the other. Align yourself and your iPad with the figure in order to minimize any inaccuracy. Try to face the middle of what you are looking at rather than off to the side. Any measurements and angles you discover can now drop down or across into your drawing. You can also sustain a visual relationship with the figure and drawing without having to move your eyes more than necessary. Ideally the only parts of your body to move should be your eyes and your arm for drawing. Every so often get up and step back from the drawing. Create a distance in order to see it again. Any obvious discrepancies should then be easier to spot.

Ensure you retain viewing consistency by facing the middle of what you are drawing. This will help you to focus on the figure without distraction and measure the information accurately. Sit facing the figure with the iPad on a table or your lap. It is possible to work with the iPad at an easel. Working at an easel is more accurate because transferring information from source to image is a smoother transition with less chance of distortion or inaccuracies. The iPad is vertical on the easel and so the relationship of the drawing surface to the figure is closer to the picture plane. This set-up is the most accurate way to transfer an angle or a measurement to the drawing. If you are standing in the right place you only need to be able to move your eyes and arm in order to make the drawing. Remember, for consistency, to be aware of exactly where you are. Stand back from the drawing every so often and see it from a distance to gauge progress.

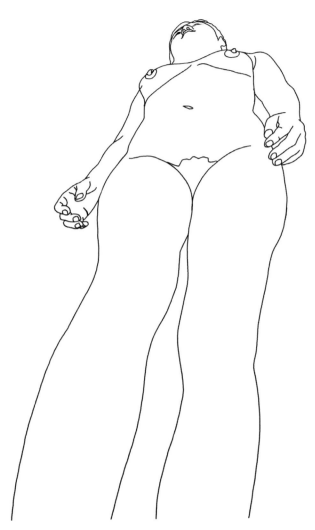

The eye-level here is very low so the model looms up high above the viewer. To get this viewpoint you would need to be sitting on the floor, or have the figure on a raised platform. The information in the figure is compressed and creates dramatic foreshortening running up the form and diminishing the scale as it moves upwards. Familiar forms and details, such as the facial features, become compressed and distorted. The legs are enormous in relation to the torso and the shoulders are hidden behind the breasts.

Choosing a point of view

Eye-level
The eye-level is exactly where you would expect. It is at the level of your eye. If you look up at the figure, perhaps standing on a table or raised above you, then your eye-level is low. If you look down on the figure, perhaps the model is in a reclining position on the floor and your vantage point is high, then you have a high eye-level. Knowing where your eye-level and horizontal line are in relation to what is being drawn is crucial to the accuracy of your drawing. This is important in relation to any angles you are trying to find

The eye-level is high. It is above the top of the model and we are looking down on her. Again as with a low viewpoint it creates drama, foreshortening and distortion. The feet and the legs appear tiny. If measured, they are about the same length as the distance between the chin and the lower forehead.

moving across the body. An extreme angled viewpoint will create foreshortening in the body.

Foreshortening
Objects get smaller the further away they are from us.

A familiar shape will alter depending on our viewpoint of it. This is the same with the human figure. Normally we are

This series of images illustrates the transition from subtle to extreme fore-shortening in the same pose. The viewpoint moves down from high to low. In this image there is a sense of looking down on the figure. Even though the figure is foreshortened, most of the figure is visible from this angle. The feet are just visible as is the lower stomach area and the body between the neck and shoulder. The pattern in the material under the figure is moving away in perspective and diminishes in size as it does so.

Moving lower slightly, the feet have disappeared from view and the head is beginning to cover more of the shoulder area. The length of the figure moving away from us has diminished.

used to seeing the figure from a number of set viewpoints. For instance, we are very used to face-to-face interaction, more or less or seeing people from the front, side and behind, either static or moving.

If we are confronted by a figure from an unfamiliar angle and we begin to draw, we can often feel disorientated. Drawing proportion and spatial relationships from these angles can seem strange. Our brains can sometimes refuse to see and accept the relationships that exist. As we measure and make comparisons our depiction can seem distorted, not just in our minds but on paper too. The measurements can seem incredibly extended or diminished from what we are used to. It feels unfamiliar because it is. This is because of the foreshortening. If the figure is lying down and the eye-level is low with the feet nearest to us,

the head will appear tiny in comparison to the feet. The feet themselves would likely dominate the composition by appearing to be huge. In fact, this is what we are seeing and this is what we need to put into the drawing, however strange that may seem.

Two well-known examples of the manipulation of human proportion in order to counterbalance the effect of foreshortening are the sculpture of David by Michelangelo produced from 1501 to 1507 and the painting of *The Lamentation Over the Dead Christ* by Andrea Mantegna from 1470 to 1480. Italian Renaissance artists were well versed in the effects of foreshortening. Their knowledge of linear perspective and the problem of depicting recession on a two-dimensional surface had been developed by Brunelleschi in 1420. Paolo Uccello, himself an obsessive in

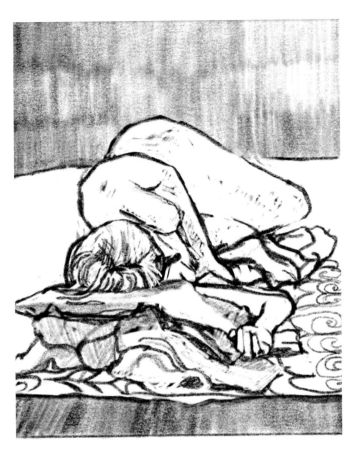

The viewpoint lowers slightly and the figure begins to overlap itself in more dramatic ways. The elbow of the left arm slightly covers the leg and the right breast is now horizontally in line with the face. The edge of the room is now visible on the same level as the shoulders. The space between the shoulder and the hip has disappeared. The figure could be seen as consisting of three major shapes, the head, the shoulder with arm and breasts and the distant hip and thigh.

This low viewpoint gives even fewer clues as to what we are seeing. Familiar information is diminished. Some parts, like the face area with the nose, and the breast are more easily recognized. The pattern in the drapery below the figure has now been compressed into a shallow space yet it is still following the lines of perspective as it recedes into the distance. The horizontal behind the figure has lowered and is now below the level of the head.

matters of perspective, was supposedly accused by his wife of being 'married' to it based on his devotion to his perfection and depiction of it.

David is a 5.17m (16ft 11in) marble sculpture designed to be seen from below. When it is on its pedestal it reaches almost 8m (26ft 3in). Michelangelo enlarged the head and the hands in order to compensate for the recession as experienced by the viewer below, and to make the proportions seem more natural and in tune with a more familiar perception. As for the *Lamentation* by Mantegna, we have the figure of Christ seen in extreme foreshortening from his toes to his head. The torso and the limbs are compressed in space. The feet have been deliberately diminished and reduced in size in the painting to prevent them from obscuring a large section of the lower body.

When considering foreshortening, it is important to drop your preconceptions and have an objective view of what is in front of you. You must draw what you see and try to eradicate the idea of what you believe is the truth based on what you think you know. Drawing the foreshortened figure means the basic familiar proportions for the human figure are completely compromised, as what you see can appear distorted. Believe it and measure it well by eye, making comparisons across the whole figure. The illusion on the paper will simulate the depth in reality. The big toe may, through alignment and juxtaposition, be as big as the distant head. This is what goes into the drawing because this is what you see. When you step away from the drawing and look at it from a distance it will make more sense.

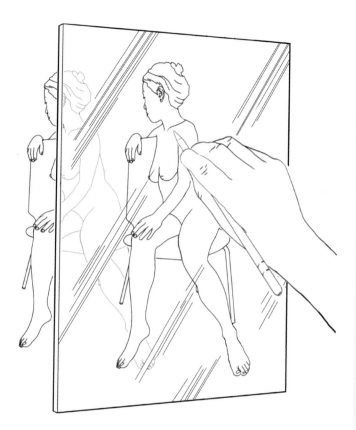

The picture plane is like an imaginary vertical window you can look through and see exactly what needs to be in the drawing. It should always be head-on to the viewer and not tilted in any way. Working with the iPad on an easel is the closest you will get to replicating where the vertical picture plane would be. However, you will never completely position the drawing surface on the picture plane because to do so would obscure the very object you are attempting to draw.

When you are drawing from life it has to be as though you have never seen a knee before, or a foot, or an eyebrow or anything and so you are discovering, or trying to see in the marks you are making, you are trying to create that knee, eyebrow, or foot afresh each time because each time it is different...See clearly and rid yourself of any memory of anything that you have seen before...and then I think you are in the right state to possibly discover the right marks to say that ear.[11]

MAGGI HAMBLING

THE PICTURE PLANE

To help you think about what you are drawing and your visual relationship to it, you should become aware of the picture plane. Imagine a vertical plane or a sheet of glass sitting perpendicular and parallel on a line extending from your eye to the centre of what you are drawing. What you see through that sheet, or we could say on the sheet, is what you need to draw accurately. If you could actually trace onto the transparent sheet the figure you see through it then you would have a very accurate depiction. The view through it is like a viewfinder in a camera. By maintaining your awareness and relationship with that sheet, ensuring it is always perpendicular to the line originating from the eye then you have a good level of consistency in your relationship to the figure and therefore you are reinforcing measuring accuracy. The spatial relationships and proportions found through the sheet are the same ones you will need to put into your drawing surface. The picture plane is the flat two-dimensional surface you are working on. This is clearly flat but upon it you are conjuring up a sense of space and accurate proportions through careful measuring and recording of the component parts.

DOMINANT EYE

To see information accurately and in focus without the possibility of seeing confusing double imaging, close one eye when taking your measurements. Binocular vision, using two eyes, allows us to see the same thing but from two slightly different angles. That is very useful when we want to understand space and distance and physically move through it. In measured drawing, using the dominant eye, we focus vision from a static, fixed viewpoint. That static viewpoint is needed to measure distance accurately and transfer the information to the drawing whilst maintaining a consistent viewpoint in relation to what we are looking at. Decide which is your dominant eye and close the other one when taking the measurements.

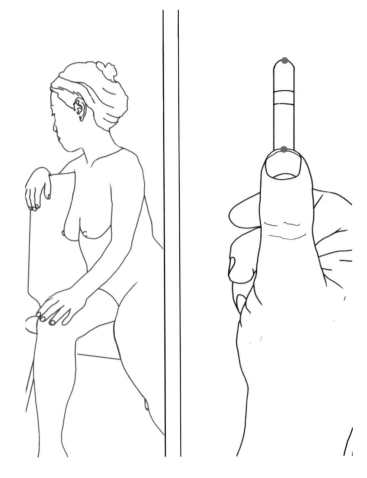

Now you can transfer the measurement onto the page, sight-size. The iPad surface is sensitive to touch and so reacts and responds easily. Be careful when laying down the information as the surface may be distracted and triggered by your hand touching or resting on it. Mark out the measurement with two dots for the head, one for the top and one for the bottom.

Take a vertical sight-size measurement from the top of the head to the chin with the pen running through the ear. Align the end of your pen with the top of the head and slide the thumb up to coincide with the chin. This is your measurement. For a sight-size drawing this is the measurement to transfer to the page. If it feels too small on the page make it bigger. You could double it. For a proportional drawing you would decide in advance on the paper or screen how big you wanted this measurement to be. Each subsequent measurement would be compared to the initial decision and would have to comply with and work to the same scale. In the early stages of the drawing, the head measurement would be the ruler of comparison against the other found measurements. As the drawing develops, more comparative measurements are made in other parts of the drawing and can be used as additional rulers.

SEEING AND MEASURING

Measuring distances across the figure can be easier if they are initially seen vertically and horizontally rather than diagonally. A simple shape such as a box has a width, a height and a depth depending on the point of view. A box is a regular shape and so it is easy to see and make basic comparisons across it. Using a consistent measuring method will help maintain accuracy.

If the height of the box is measured and compared to its width, you are discovering the relationship between one side and the other in order to help you understand its proportions and so draw it accurately. A measurement between two points on the figure could be used again and again to make comparisons. It can be turned on its side to measure horizontally. The width of the box might be exactly the same as the height or maybe one-and-a-half times bigger. Take one of the measurements found by using your pencil or pen and compare it to the other. What is the difference?

Making comparative measurements

This diagram illustrates how the head height measurement, as recorded by the distance from the thumb to the end of the pen, can be turned on its side and used to make comparative measurements across the figure.

It is not necessary to begin a drawing with the head in the vertical. Each pose is different and it may be easier to start in an area that seems easier to read. The method described here is a recommendation and can be adapted.

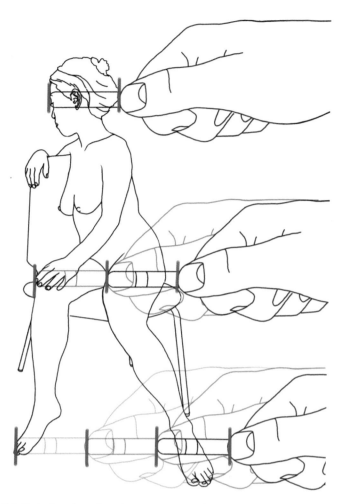

This illustration shows how the measurement of the head can be turned and can be applied to make comparisons across the width as well.

TAKING A MEASUREMENT

You can use your stylus, iPencil or any other straight-edged tool to make a measurement. Hold it out at arm's length and close one eye. Use the top of the pencil as one end of a measurement and slide your thumb up and down the body of the instrument in order to locate the other end of the measurement. To begin the drawing, look for measurements in the vertical. Identify an obvious point on the figure and imagine a vertical line extending up and down through the figure. Along this line identify other significant points. Using the stylus or a ruler take readings or measurements and mark on the line to denote their position in relation to each other. This will establish points of reference and points from which to build out sideways with further measured information.

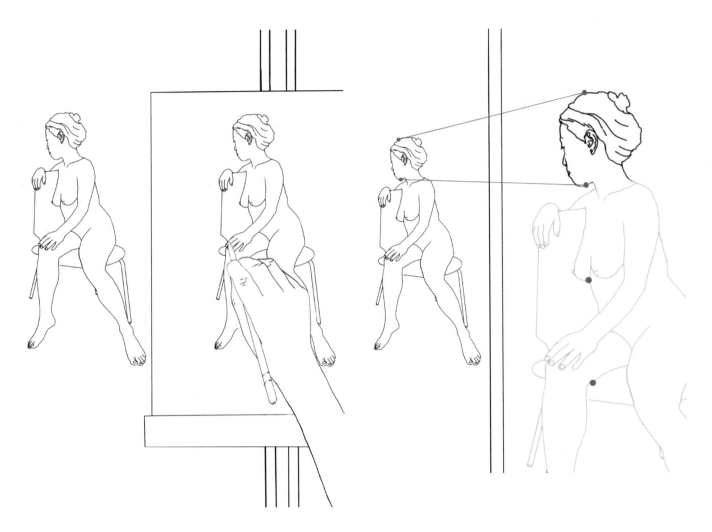

A sight-size drawing should be, if it is accurate, the same size on the paper as the figure is from where you saw and made the drawing.

This illustration shows how a scaled-up drawing can begin. The head height on the paper is larger than sight-size, almost twice as big. The decision to make the head height this scale can be based on any number of preferences. One could be the intention to fill the paper with the figure from top to bottom and so make it bigger than sight-size. Notice this measurement is repeated down the imaginary vertical line running through the figure.

MAKING A MEASURED DRAWING

1

Put your arm out straight, close one eye, stand still, face the figure and be aware of your position. Take a measurement of the head height with the pen: the top of the pen in line with the top of the head, your thumb in line with the chin. Make sure the pen cuts through a significant point in the head, in this illustrated case the ear, which can act like an anchor.

SIGHT-SIZE DRAWING OR PROPORTIONAL DRAWING?

How do you make a drawing that is not sight-size but is bigger or smaller? A drawing can be any size you want as long as you maintain the proportional relationships between its parts. Decide how large one element will be and this effectively will set the proportion for the rest of the drawing.

If, for instance, you begin with the height of the head and draw that as 10cm (4in) onto the page or screen a commitment has been made regarding the scale of the drawing. That decision has set the proportion and it will be your first unit of measurement. The rest of the drawing now has to work to that scale in order to match it proportionally. So if there are five head heights down through the vertical to the left foot, for example, the foot will be 50cm (20in) below the bottom of the head measurement. If the head was only 3mm (0.1in) tall the foot would be 1.5cm (0.6in) below it. All the proportional information comes from the subject. Once the drawing is underway and information has been recorded into the drawing it is no longer necessary to use the head as a unit of measurement. There will be other elements available that might be smaller or larger that could feel more appropriate for making comparisons across the body. It is because they are all working in relative proportion to each other that the drawing will maintain its accuracy and work as one complete figure.

A decision needs to be made as to whether the drawing is proportional or sight size. Considering how easy it is to move in and out of the drawing on the iPad, a proportional drawing would make more sense. A sight-size drawing would rely on maintaining the same overall proportion to what you are seeing. Once you zoom in and out that relationship might be compromised somewhat and it may be difficult to get back to the exact same proportion on screen.

If the measurement is used exactly as found, without scaling up or down, then it is a sight-size measurement for a sight-size drawing. Clearly the size will be determined by how near or far you are from the model. If your drawing feels too small then move closer to the model. If too big, move away slightly. For example, the width across the shoulders, when measured, may be 3cm (1in). This measurement will go into the drawing as 3cm (1in) in a sight-size drawing. The whole figure will appear at the same size in the drawing as it has been seen from your particular point of view. If you were to move closer to the model the measurement across the shoulders would increase, or decrease if you moved away.

2

This is a sight-size measurement. Onto layer one, transfer this measurement to the screen and continue it as a sight-size drawing if you choose or make it a proportional drawing. Make two marks on the screen, one above the other to represent this measurement.

Like a piece of paper, the iPad Pro screen will not get confused if your hand rests on the drawing surface. You do not need to hold your hand away from the screen to draw as it can distinguish between the pen and the hand: the hand is prevented from drawing. However, for complete rejection it is possible to disable all hand-drawing gestures in Procreate. In the app, look for the preferences option. Select 'gestures only' in the advanced gesture controls. This will only allow the iPencil to draw on the screen. If you are using an iPad other than the Pro take care when transferring information to the screen. It may help to have two implements, one for measuring and the other, a stylus, for marking the information on-screen.

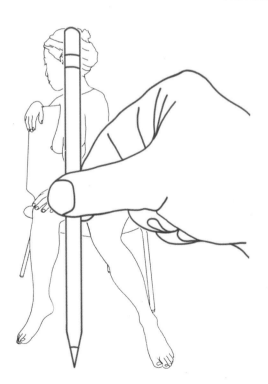

Use your pen to sight the vertical you want.

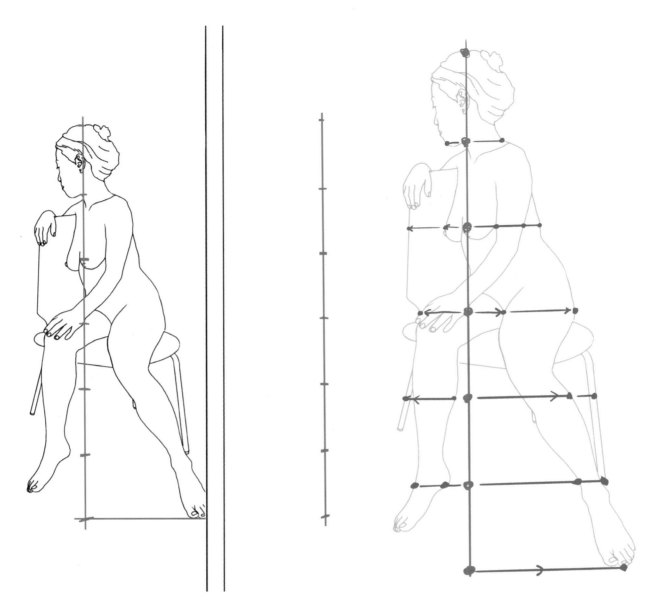

The vertical and its divisions have been transferred to the page at sight-size.

From the vertical points, look out horizontally in both directions to key points, measure and mark in. This information can act as a reference layer, keeping the drawing in proportion.

3

Go back to the figure and run the pen vertically down the line you discovered in the head. Carry the line through the body. Along this line there will be significant visual points that will be selected and transferred to the drawing. These might be, for example, where the crease line of the breast ends on the left side, the belly button, the edge of the knee on the right leg, the heel of the left foot. Each pose will be different. Do not choose too many or else it will get too complicated. Choose clear and significant points.

4

Move systematically down the vertical line, marking off the points onto the drawing on layer one. For sight-size, transfer the measurements between the points as seen. For a scaled-up drawing compare the distance between the points and calculate the proportions. Take the ratio of the two, it could be 1:2. Use the head height, already drawn on the screen, as the ruler to compare against. Mark in the points accordingly.

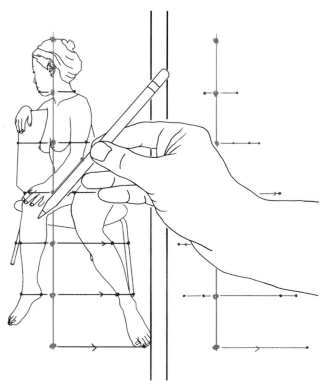

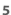

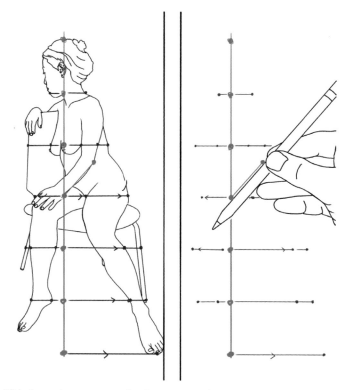

In addition to making sight-size measurements across the horizontals begin looking for diagonals that cross or sit on the same line. Use your pen to see the angle between two selected points. One point should be existing and significant, emanating from the vertical. Using your dominant eye, align the edge to the angle and then mark it in. The human figure is not actually made up of straight lines so this line represents the straight line relationship between two chosen defined points. At a later stage, draw in the actual configuration and shape of the line between the points, being careful to reflect the subtle bumps and dips as well as the more obvious curves.

If it is a sight-size drawing, mark in the found measurement. If you are making a scaled-up drawing, compare it with another distance in the figure and scale it accordingly. It could be the width of the waist from one side of the body to another, running through the navel.

Glide the angle over to your drawing as accurately as possible and mark it in.

5

Once you have a number of vertical points marked in, look for some horizontal measurements to determine where other parts of the body are. Make either sight-size measurements or proportional measurements based on what you have already drawn. Mark them in. The drawing will look like a series of dots and lines indicating where the body will be when the lines are added in layer one.

As you progress through the drawing it may be that you need to zoom in to add detail. If your existing information is accurate you will be able to continue working on a small

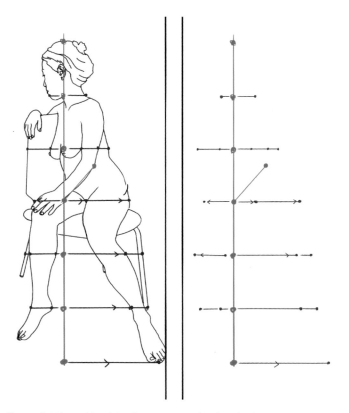

The angle is in position. It has been measured and marked in as either a sight-size or proportional measurement.

section without necessarily knowing what is happening in the unseen sections of the drawing off-screen. Effectively, layer one is a reference layer as it has the proportional information relating to the key points as seen and plotted in initially.

One of the drawbacks of working on an iPad can be screen size. The iPad Pro is roughly the size of an A4 sheet of paper. It is possible to make a complete drawing on this scale without having to zoom in for detail. That means a sight-size drawing is feasible. If your screen size is smaller zooming in may be a necessity as details in the face for instance may be too small to measure in sight-size. Making a sight-size drawing would require you to avoid zooming into the drawing because once you do this you have altered the on-screen drawing scale in relation to the actual figure. Unless you re-establish the same exact relationships between screen and figure it will not be possible to continue as a sight-size drawing. You can, however, continue it as a proportionally sized drawing.

Always be guided by your own eye and perception and do not doggedly stick to the rules. Use the rules as a guide as proportions vary from individual to individual.

6

Select a second layer over layer one. Now you have choices in how to proceed with the drawing. The drawing should start building using a combination of the following approaches:

- Begin looking for angles between two points. Use your pen to find the angles in the same way as you make measurements. In the illustrated example, the angle from the wrist to the elbow is transferred to the drawing from the source. The wrist is along the vertical line. The angle between the two is a straight-line relationship. The line is the guide for the actual line of the arm which bends and curves between the points. Look at the curve. If it has a relatively simple shape, draw it in. If it is more complex it may help to split the space into sections representing where curves change directions and their proportions to the whole. Use layer two as the layer for determining angles and additional points to layer one. Any actual lines describing the curves and detail of the body will be placed on layer three. This layer will contain the final drawing. It may be necessary to move between layers two and three as required. Instead of erasing the workings of the drawing as you might on paper, the previous two layers can be hidden in order to conceal distracting lines, dots and underdrawing.

- Keep on adding markers for significant points as you discover them. Eventually, you will come back to them all systematically and they will be amalgamated as the drawing proceeds. Take care not to put in too many or else it could be difficult to remember what they represent. If your measuring is inaccurate these points will show that later as they may not dovetail with previously discovered information.

- Mark in either sight-size or scaled-up. Complete the line describing the journey between the two found points.

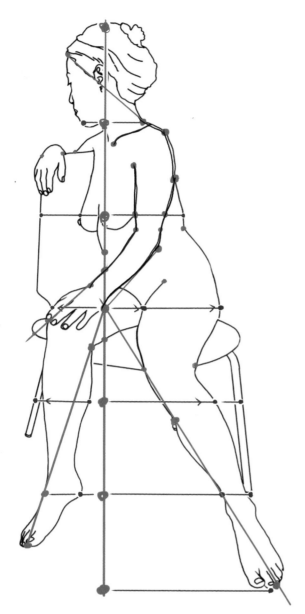

Begin looking out, measuring and finding angles from existing points to build information about the relationships across the figure.

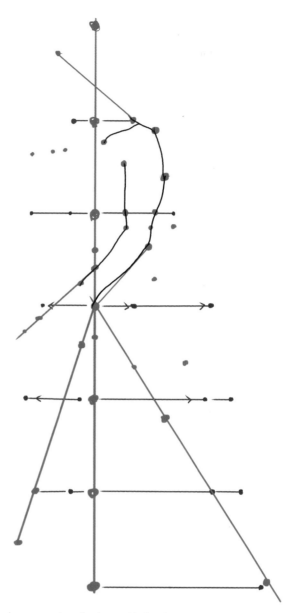

Once you have a number of points and before it gets too complicated, connect and draw in between some of those points to find out where the figure is and give yourself a better chance of knowing where everything will go.

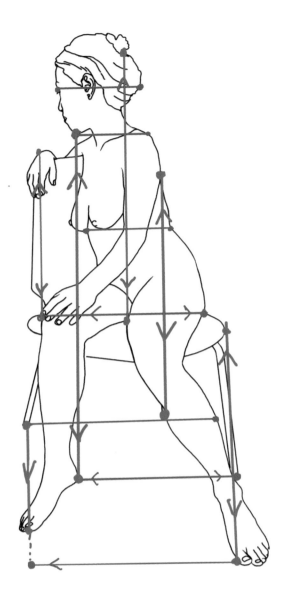

Every so often, create a vertical or horizontal line to cross-reference points that are in alignment with each other. Do this with your drawing tool rather than on the drawing. It may be that you use your pen to find out what is in the horizontal alignment to the right from the left elbow, for example. Whatever you discover, take that information to the drawing and check if it matches. If it does not, you have an inaccurate drawing, or the model is moving.

7

Continue working between layers two and three finding points and angles, joining and connecting, focusing on particular areas that are making good progress. Do not veer off to an extremity and work on that without having built a clear solid path to it with previously found information constructed from the core outwards. The drawing should build like scaffolding, feeding off itself rather than created in random sections that run the risk of never joining up accurately with each other.

If possible, contextualize the figure. The pose is determined to a degree by what the figure sits or lies on. This information is useful. Often it is geometric so sometimes it is easy to record its measurements. It can run across or behind the figure providing valuable and helpful relative information to reinforce the accuracy of the drawing.

Everything you look at and focus on has a relationship with its immediate surroundings. Consider the surroundings as a helpful source of information for scaling and placement.

The horizontal will prove extremely useful when looking at the diagonals across the body and trying to determine their relationship in any given pose. In a head-on standing pose the angles across the eyes, shoulders, hips, knees, feet and breasts will be aligned in the horizontal, more or less. Once a pose is taken up, these relationships will change and reading the diagonals in relation to each other and the horizontal line will be very helpful.

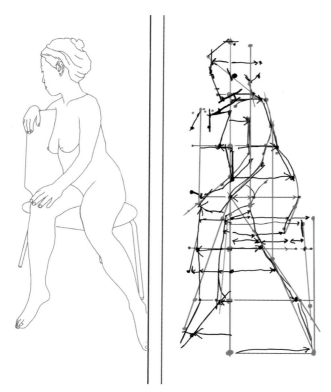

Continue building up the drawing by finding and marking in points and angles. After a while, the drawing should be well underway and will begin to feed off its own information. Step back occasionally and look at it from a short distance.

Eventually you will arrive at a complete line drawing. Close down the layers you do not need and you will have an accurate measured line drawing of the figure.

8

As the drawing builds up, it is critical to cross-reference the points as often as possible. Every so often, drop an imaginary vertical line down from somewhere high up in the drawing to see what it coincides with on its path. This could be done on a fresh layer. Check the information found against the figure or use the figure as the source and check that against the drawing. This should, of course, be done in the horizontal too, especially if it is a lying pose. For a lying pose, horizontal alignments would be more appropriate but vertical ones are still valid. Again, check the information in the figure first. As an example, run across from an obvious point horizontally and see what coincides with it along the line. It may be that it becomes obvious that the hip is actually below the horizontal as opposed to above it. If the information does not add up, you have a problem with accuracy. This will need to be corrected as soon as it is discovered because if you do not it will always be there.

9

Build the drawing slowly, still cross-referencing. Continue until the drawing is complete. When it is, close down the layers you do not need anymore leaving just the drawing layer or a combination of them.

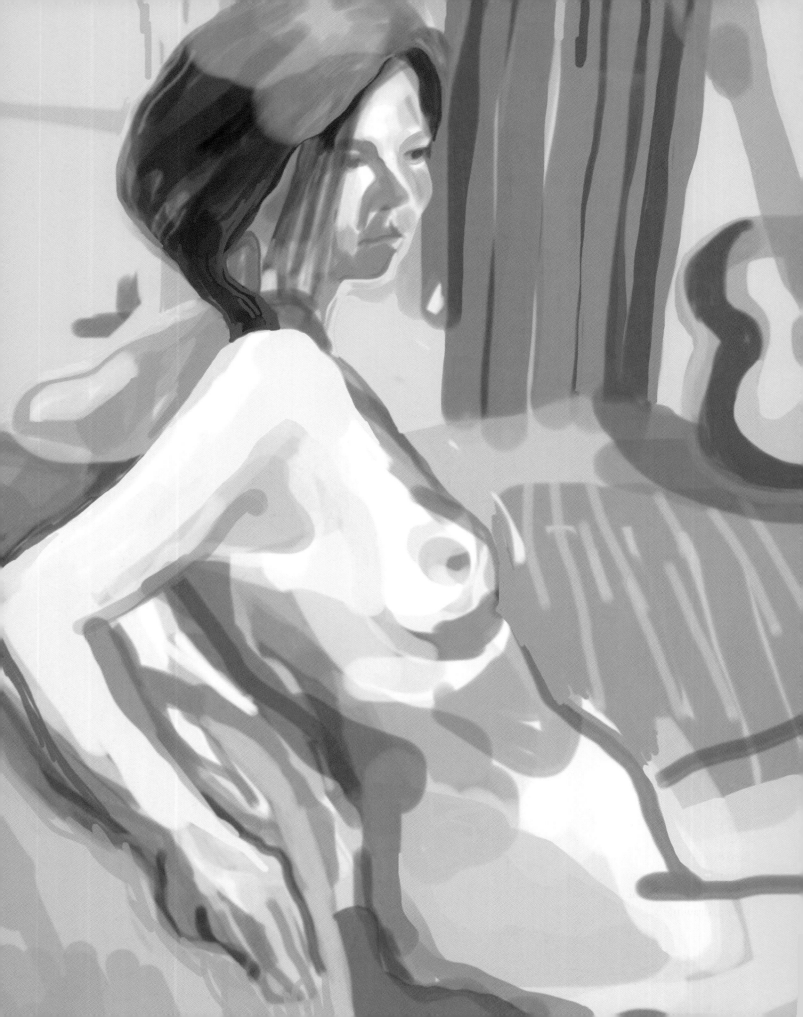

Tone

Relief is...the soul of painting[12]

LEONARDO DA VINCI

'Relief' in this case was in reference to the illusion of projection giving the appearance of the third dimension. We can use tone, or 'shading', to depict a believable and solid-looking figure within a definable space. The struggle will lie in creating a convincing illusion of three dimensions on the two-dimensional surface. The drawing requires the viewer to read it spatially. Any subtle discrepancies will be quite obvious. The aim is to draw the figure showing the gradation of tone set within a believable space. We have to see and understand the signs that communicate this and set them down. We shall approach this through a series of ideas that will be amalgamated into a complete tonal drawing. The next chapter takes the basic ideas of seeing tone and explores different ways of making tonal drawings.

The first drawing idea is to establish the basic flat tonal shapes simply using black and white. This drawing can be created on a single layer or it could made with a combination of two layers using a basic drawing or painting brush in combination with the eraser. The next drawing will look a little deeper and begin to consider the actual form of the figure rather than just flat shapes. In this drawing the differences between the tones will be identified and keyed in in direct relationship to the lightest and darkest tones. The final drawing will combine the first two and set the figure within its context or surroundings.

There are additional key considerations when fine-tuning a tonal drawing:

- Firstly, form and lines do not mix, in this case. The figure is not described by and contained by lines. The figure appears solid because it suggests three dimensions.
- Secondly, at certain points the tones in the figure may be identical to those around it. This means if the drawing is monochromatic or without colours the figure can occasionally blend and disappear into its surroundings. This is known as lost-and-found edges.
- Thirdly, shadows and bouncing light must be considered. Throw light onto a figure in a room and the effect is not predictable. The question could be what kind of shadows are we drawing and what effect does reflected light have on the tones?

MAKING MARKS

In painting and drawing it is always possible to explore the same idea in a number of ways, using different materials and approaches. This is what makes it interesting and can bring a new impetus and energy to the work, revealing possibilities for further development and altering our methods of making images. In terms of options for exploring mark-making and creating tone, the more sophisticated drawing apps will have a very comprehensive range of choices. The convenience of being able to choose and change the brush settings at the flick of a finger gives the artist the ability to easily avoid repetition and uniformity.

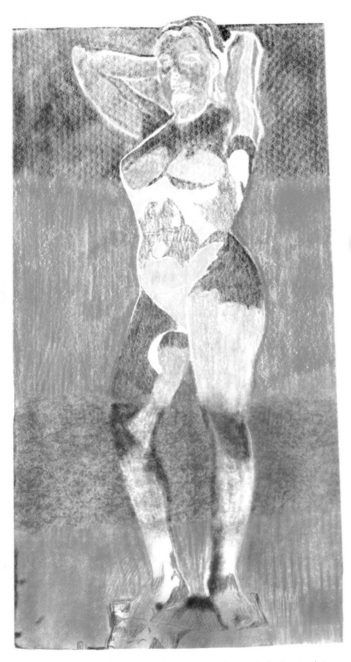

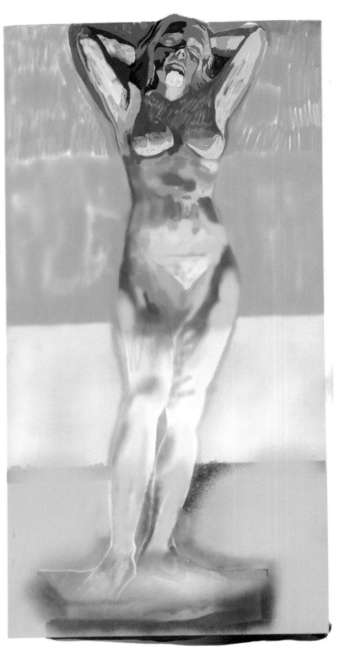

These three drawings demonstrate how tone can be created using twelve different brushes. Each drawing is divided into four to show the potential uses of the chosen brush. This drawing explores four brushes based on dry media found in Procreate. Notice how the texture of the paper itself is a feature of the mark, especially in the Soft Pastel choice. The texture is simulated as the marks are made. From the top the brush names are: Soft Pastel, 6B Pencil, 4B Compressed Charcoal, Willow Charcoal.

This drawing is based on a number of airbrush styles. They are: Hard Airbrush, Soft Brush, Medium Nozzle, Fat Nozzle.

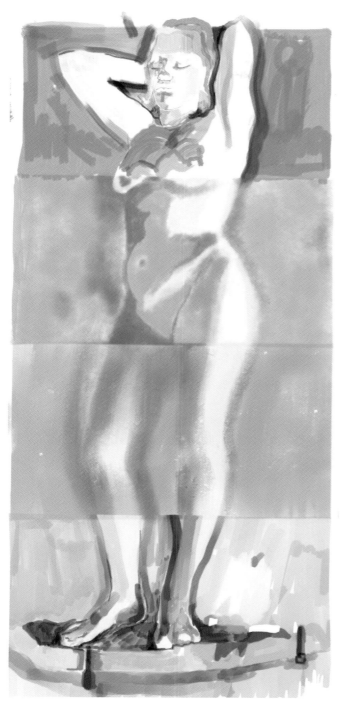

The third drawing uses brush styles intended to simulate traditional brush-painting types. They are: Flat Brush, Water Brush, Damp Brush, Round Brush. These drawings are based on a series of three sculptures found in the Alcázar in Seville.

The iPad drawing apps will give you an enormous array of brush styles to choose from. To begin, choose a basic brush style that is easy to control and does exactly what you need it to do. The emphasis for now will be on looking and getting down what you see without added difficulties.

The mark-making tools in Procreate are known as 'brushes'. The range of brush options is vast and can be almost overwhelming. In time, your favourite brushes will emerge. Some will do exactly what is required of them. Others might seem inappropriate, outlandish and unwieldy. All the brushes have great potential, even the more familiar ones. Keep experimenting in order to make discoveries.

The term 'brushes' implies a brushing effect, and the brushes available to you will include mark-making tools that simulate the effects of a brush itself. However, there are also a number of 'brushes' based on drawing media such as charcoal, pencil and pastel. These imitate the effects of more traditional dry mark-making tools. In addition, there are categories that would seem more off-beat, less traditional but will yield dynamic results. Trying them out and getting them to work for you is all part of the fun and struggle of being creative.

Within each category of brush there will be further options of related styles. In Procreate, there are sixteen standard brush choice styles, such as painting, sketching, charcoals, artistic and airbrushing. Within each style heading you have eight choices of brush. That would provide 128 options of mark-making tools to use in your drawing and painting. It is also possible to design a unique brush style to add to the existing choices based on your own shape and grain. Every individual brush has the capacity to be fine-tuned to your requirements by considering such things as its streamline, spacing, opacity, size and jitter. By experimenting with the familiar and less familiar brushes you can discover configurations of the same brush style that will open up even more mark-making approaches and possibilities.

COLOUR AND TONE

Tone is the lightness or darkness of a colour. All colours are tonal. Seeing the difference between one colour and another is easy but seeing the tonal differences between colours can at times be difficult. Tonally, colours can be identical and yet at the same time their actual colour can be strikingly different.

This collage demonstrates how tone in colour works. The image on the left is made up of a range of colours. The image on the right is a black-and-white version of it. Note how the tonal range in the black-and-white version is very close whereas their colour equivalents in the original are in some cases at extremes to each other even though they are very close in tone.

For this chapter on tone we are drawing and painting a range of values seen between black and white. When we are looking at the figure we are seeing in colour. This means we need to convert a colour seen to its equivalent grey, however dark or light that might be. You will need to understand the difference between colour and tone.

If we were to paint a range of colours, identical in tone, onto a sheet of paper and then photocopy the sheet in black and white the tones would all blend into one. The colour would have gone and we would see a solid, uniform bank of grey.

When drawing we tend to use a range of tones between the two extremes of black and white. It is unlikely we will have to use an absolute black in the drawing. Some light exists in almost all shadows. When depicting the light, it is likely that the actual surface tone of the paper would be reserved for our lightest light. This is as light as we can draw without using a white as an additional colour. Between the extremes we might perceive a vast array of subtle grey tones or just a few. It depends on the quality of the light, the qualities of the surfaces the light strikes and their configurations. The movement of tone from white through to black is known as the achromatic scale. To draw spatially, it is important to see and understand the values of tone and the relative differences between them in order to pitch them into the drawing at the right level.

FLATNESS AND FORM

The figure will have a number of different tones across its surface. The tones provide information about its form and density. Without tonal variation the figure would appear to be almost flat. This could be the case if it was lit head on from our vantage point. Most of the form would look flat as the shadowing would be diminished. A flat piece of paper looks flat as there is no variation in its form and the light across it is even. If the paper is creased and its flat state is disrupted, this alters its relationship with light. Light strikes it in different ways as its surface now has the third dimension. The evenness has been interrupted and it has tonal variation. The tones reveal an object's form as it responds to the light. They also help us to understand its spatial relationship to its surroundings.

DRAMA IN TONE AND COMPOSITION

Light and the use of light have a crucial influence on the design and impact of a drawing or a painting. Contrasts of tone and their placing can give movement and rhythm to a picture, adding depth and drama. Caravaggio exploited these ideas to great effect in the seventeenth century and as a result he was a highly sought after and influential artist. His paintings were realistic, almost super-realistic. The ability to get closer to the action or to God was their appeal to the church commissioners and the devoted too. As Caravaggio knew full well, light adds drama and if we control the light we can control the drama. His aim was to make the extraordinary story ordinary, convincing the devoted to believe in the reality of the scene.

Caravaggio directed the scene to his specific requirements, in a similar way to how a film director might orchestrate and light the actors. His paintings feel theatrical and staged. The action takes place within shallow spaces, capturing the players in sharp relief. This also has the effect of involving the viewer by limiting the attention to the main players instead of allowing distraction by anything non-essential.

Apart from the extreme contrast of tone, excitement is also generated by the carefully considered compositional arrangement of the lit and shadowy forms. He presents lingering bodies in the shadows with, at times, dramatic foreshortening, figures in half-light, with cropped heads, overlapped and obscured by more urgent action. These elements draw our eye across the surface of the painting with varying intensities of detail and movement. The carefully selected highlights seem as if lit from a single spotlight illuminating the required action in order to tell the story in clear and powerful detail. This brings us in, connecting us more deeply to the narrative to the exclusion of the outside world and so provoking the contemplative.

Having control of the lighting meant Caravaggio could guide the viewer and make the composition show what he needed it to in order to deliver the message required. He took no chances, avoiding uncontrollable multiple light sources. It is important to be aware of the light source and make it work for you.

This is a copy after Caravaggio's *The Flagellation of Christ,* 1607. This copy demonstrates the dramatic arrangement of extreme light and dark rhythmically moving across the surface of the composition.

Artificial light can enhance representation of the volumetric by causing every plane and hollow to be shadowed and projections highlighted, unlike the flattening effect of very bright daylight.[13]

DEANNA PETHERBRIDGE

LIGHTING

The light source determines the variety and strength of the tone and how it moves about and reacts to the space and the figure. In natural light the tones will be changing slowly in time as the Sun moves across the sky or changing quickly and more dramatically depending on the weather conditions and time of day.

A badly lit set-up could still be interesting for a number of reasons but not as engaging as it could be if the lighting was considered more carefully. Many life-drawing sessions are marred by a lack of consideration in the lighting of the

This image shows how the tones across the model are seen and set down in the initial drawing stage. The light falling across the figure has been simplified and identified as either black or white, dark or light. Mid-range tones have been absorbed into either camp. By squinting it is easier to see the basic division. Accuracy of shape and proportion are important to maintain even though this appears to be a 'simple' drawing. The detail is in the accuracy of the shape and how it sits with its adjoining shape or shapes.

These three drawings show in extreme contrast the distribution of black-and-white shapes moving across the figure in response to the light falling on them. All mid-range tones have been amalgamated either towards the white or the black side. This drawing shows a draped figure lying on a mound of material.

model. Exploiting the lighting possibilities and getting this element right are integral to the pose and subsequently the work itself. The lighting is as much a part of the action as anything else.

When you begin studying the effects of light and tonality it is easier to see the model lit in high contrast as the tones towards light and dark are more extreme. Artificial light allows for a greater degree of control and manipulation and you can organize the set-up according to your needs. This means you can design and direct the action to reveal or conceal, to a certain extent, what you would like to draw and be seen.

LEONARDO DA VINCI AND LIGHTING THE MODEL

As you would expect, Leonardo da Vinci was a little obsessed with the uses of natural light and its effects on his models. He is well known for his enigmatic use of tone, known as 'chiaroscuro'. For him the ideal light fell at 45 degrees. He disliked direct sunlight, advising the student to avoid light that casts a dark shadow. He liked to imagine a transparent mist had descended between him and the object being painted. This was the effect he sought when working outdoors. He was drawn to the gentle light of high-walled streets and its ability to radiate light within the shadows so the faces were 'deprived integrally of every harsh boundary' and they 'appear full of grace from a distance'.[14]

The lighting can be maintained by using independent light sources providing a range of changeable lighting possibilities in a stable and convenient environment. An in-depth tonal drawing is likely to be fairly time-consuming and the more time you have without a change in the lighting conditions the better.

The changeability of light will have a bearing on the kind of drawing you can make and subsequently its result. Maintaining the required light in daylight might be difficult as the light can change unpredictably. This will compromise your pose and approach. A particular set-up might alter too quickly for the process of working. Northern light is a reliable option as it alters less over the day. Lack of sustained available light could mean you return to the drawing several times at a specific time of the day over a number of days to maintain light consistency. Or it may also mean completing one painting in a single sitting within a set time limit. Whatever happens, the two approaches in response to light will likely yield different results.

This drawing is of a male reclining figure. Even with such a limited amount of information we are able to read very clearly what is going on in the pose.

This drawing is of a seated female model. Notice how more of the background space has been included, providing a context for the figure to exist in. Even though these are flat black-and-white shapes the space is suggested by the overlapping of shape and tone. The female model is sitting on a chair with drapery. Beside her legs you can see a heater and the simplified torso of a mannequin. Behind is her shadow and the suggestion of two walls coming together.

SEEING THE LIGHT AND THE DARK

In order to produce a tonal drawing, start looking for simple tonal relationships. To begin we need to see, understand and draw tonal shape and later tonal value. Tonal value is the difference in lightness or darkness. These different values will be used, in conjunction with the shapes, to help create three dimensions illusionistically. To record tonal shapes we should break down the arrangement of different tones into accurate flat shapes like jigsaw puzzle pieces.

Select a layer and add an all-over background tone. This should be an all-over mid-range grey. Choose a second layer for your actual drawing and use only black, white and the eraser tool to help you adjust your shapes. The tool should make a consistent and fairly solid mark with the option to make it wider for filling large areas and thinner for detailed edges.

We are not trying to create a convincing three-dimensional figure yet. This will be a drawing with no real suggestion of depth. It is a flat drawing. If the model is lit dramatically in strong contrast we should be able to divide the figure roughly into tonal patches or shapes. Strong directional lighting will emphasize the tonal arrangement, making it easier to see the shapes and so helping to isolate them.

The values will vary from high to low with perhaps some tonal range between them. Some will be more subtle or obvious than others. Squint away the distracting detail and look for dark and light only. What is lit and what is not. Try to identify the two extremes, one black, the other white. Identify the shapes of each and draw them out. Draw using a combination of the brush and the eraser. The eraser can be set to the same setting as the brush so the marks made are consistent. Draw with the eraser, cutting into the

already drawn shapes and adjusting them for accuracy and proportion. The individual shapes placed in conjunction to each other should give the illusion of a flat figure, in extreme lighting conditions, white coming from one side with the darkness on the other.

TONAL VALUES

Discerning between tones and drawing one tone against another are crucial if you are to convincingly show the form. You will need to practise making tonal comparisons and getting the correct relative values into your drawing. In addition, working directly from the model means looking at colour and you will need to be making judgements about the tone of a colour. That can be difficult to distinguish. Squinting may help as it seems to diminish the colour itself slightly.

Before considering the more subtle mid-range tones within the figure it is useful to familiarize yourself with the tools in the app and make a tonal scale. As an exercise, create a value scale on your iPad showing a smooth gradation of tone from white through to black. Digitally this will be easier than with paint or a drawing material like pencil or charcoal as it is simply a case of organizing the colour picker, making a mark and incrementally moving the tonal slider from one end to the other, making additional marks at each stop.

LIGHT ON DARK, DARK ON LIGHT

When we begin with a blank white sheet of paper we have a surface that is as white as can be. We can get no whiter than that. Therefore the lightest element we draw has no choice but to equate to the whiteness of the paper available. Everything else will be tonally darker than that extreme light. That is our lightest light. By covering our surface uniformly in a mid-range tone we are getting closer to what we are actually experiencing. The toned surface reflects more realistically the average tonal dark value that surrounds us, either in a room or outside. We tend to add a darker tone to lighter paper.

It is light added to the all-surrounding darkness of the universe that permits us to see. Only in the presence of light does seeing exist. By drawing onto an existing grey and adding darks or adding lights, it is easier to organize the tonal comparisons rather than building up all the tones from a stark white sheet. The drawing begins with the general tonality and the light reveals the form spatially through the process of adding darks, subtracting lights, shaping, blending, and adjusting tonal values and shapes.

Choose the non-classic colour picker in Procreate. Select a fairly neutral coloured flat background in order to see your transitions and prevent some shades from disappearing. This will create a good base to see the tonal study from white to black.

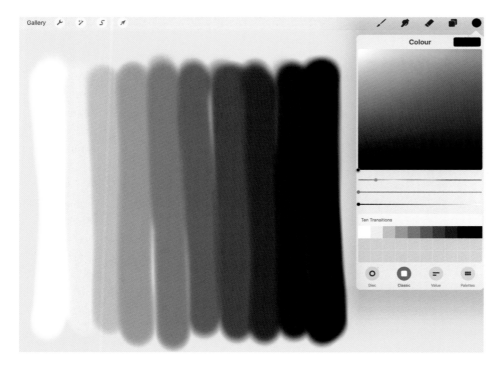

This screenshot shows the tonal value exercise in ten transitions. The Soft Brush tool from the Airbrushing option has been used to paint with. The painting is made on a prepared layer of an off-white all over colour. This could be done on the background layer in Procreate. The actual transitions of tone exist on their own single layer.

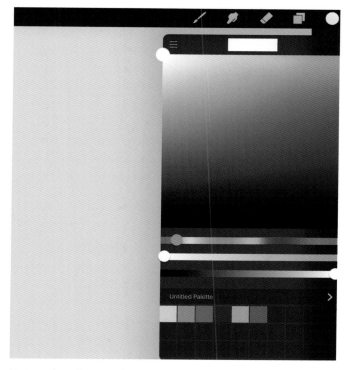

Fifty-five shades of grey. The tonal increments can be as numerous as you wish. Here the challenge is to extend the idea and see how far it is possible to push the subtle gradations without losing clarity as the tones move slowly from white towards black.

Notice in the colour picker the three horizontal settings have been prepared for the exercise. The settings show the position needed to create the variable grey tones from white to black. The top setting shows the colour of the palette that has been used for the neutral background. This palette is now being used for the transition from white to black and is set up accordingly. The middle setting denotes the colour saturation. This is set to the extreme left where it will stay as we do not need any colour. The lowest cursor is tonality. This is also set to white to the extreme right this time. For each stroke, this cursor needs to be moved towards the left side in equal increments. At the same time the indicator in the square colour box moves down the left hand side each time from white to black ending at the bottom left corner.

Tones between black and white

The second tonal drawing of the figure will build on the previous one wherein flat shapes in black or white were identified and slotted together to show a recognizable figure. Now additional shapes will need to include more of the subtle mid-range tones between the two extremes. Prepare the paper or background layer as previously with a mid-range tone. Put in your first shape and relate it to its adjacent shape to help you make a coherent drawing. It is important to create the drawing by looking at one shape and the next shape along, either across, up or down. In a way you could liken the construction of the drawing to scaffolding. One piece informs and determines where the next shall go. Do not focus solely on all the light shapes first then all darker shapes. That would be too haphazard an approach. By not drawing adjacent shapes and building the form in a sequence of related shapes it is harder to maintain

the proportions accurately thereby jeopardizing overall unity. The next piece cannot go in unless it is relating to the previous one. The shapes are like jigsaw pieces that slot together. At a fairly early stage, check the proportions. Focusing on shape and tone may compromise proportional accuracy so it will need checking every so often. If the proportions are too far out it will create some visual problems. Correct as necessary as you notice the inconsistencies.

Approach the work in the same way as before, squinting and identifying a tonal shape to set down. This time you will make a tonal comparison between the shapes. Ask yourself, is this shape lighter or darker in tone than the next along? If so, by how much? The tonal extremes provide a comparison guide for you to work with. It may be after making comparisons that your initial tones were pitched too light or too dark. Adjust as appropriate before you continue. There will still be an editing process going on as some shapes will have even more subtle gradations within them. Be quite general to begin with and consider the basic tone of the shape and how it differs from the next. The much more subtle shades within it can be left for now and inserted at a later stage when the principal shapes and values have been established. Do not get involved in tiny detail such as fingers and particular facial features.

Resist the urge to make a complete linear drawing of the figure in advance which you then 'fill in' with tone. This will be counter to the aim of the approach. If the linear figure is out of proportion the tones will not go into the right place.

Do not feel restricted by the size of your drawing on the screen. Planning out the drawing across the page can sometimes slow you down and distract you. Perhaps you began too large or small, or maybe in the wrong place? This may be a problem to resolve on paper but not so on the iPad. If drawing on paper, you could start again or add more paper. With Procreate on the iPad the drawn image can be altered in every layer used in order to reconfigure its relationship to the four sides. This is an opportunity to easily experiment with composition, scaling and cropping. Use the transform mode icon to highlight the contents of the layer. Apart from moving and scaling, the layer can be transformed using the nodes found on the encompassing dashed line.

By building tonal forms in relation to one to another we are creating form as we go along and are thus thinking directly in three dimensions as the drawing evolves. It is a much more solid approach. It may be necessary to use some lines as outlines to describe your shapes or to plan the proportions and dynamics of the figure. Keep all lines in check and do not over-describe with line.

A fairly recognizable figure should be emerging, albeit devoid of detail, but it should suggest an object that is lit intensely from one side with shadowy shapes on the other side, that looks solid and three-dimensional.

Blending tone

Notice in the sequential series of drawings that some of the tones are blended softly whilst others are hard-edged. Blending will take practice in order to get it as seamless as you need it to be. Some brushes are easier to blend than others and it is useful to try blending with as many as you

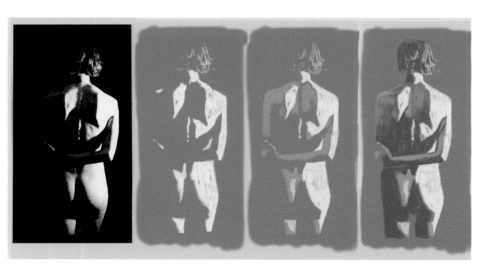

The black-and-white photograph of the model on the extreme left side shows the light coming from the right, creating clear highlight shapes. This can be drawn as an arrangement of lights as seen in the stage-one drawing, second from the left. Stage two begins to introduce a mid-tone between the highlight tone and the overall mid-range tone. The shoulder on the left is emerging from the background as is the shoulder blade on the right. Stage three on the far right brings in a darker tone.

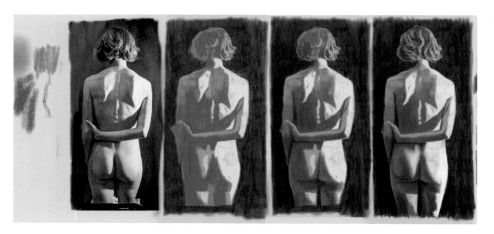

The black-and-white photograph here of the same pose includes more subtle tones so the contrast is less extreme, providing more depth and definition. The stage four drawing in the series of six overall has now adjusted the proportion of the figure. A darker background tone has been added to create more relief for the figure. Drawings five and six continue to add darker tones, blending and defining edges in the more subtle areas. This drawing was made using the Vine Charcoal tool in the charcoal option.

can. With some brushes the mark made is very distinctive and this can make blending difficult. The easiest brushes to use are the ones that approximate drawing materials well. These might be the charcoal and pencil options.

There are two basic approaches when dealing with tone. The first is to simply add more drawn layers over those already existing, building up the darkness. Be careful not to go too dark and end up with a dark that looks dead as it has no suggestion of light in it.

Over an existing layer of tone, gently add extra layers. Your brush opacity setting will need to be adjusted to the strength you need in order to maintain control and slowly blend in the darker sections. For a subtle build-up of tone, set the opacity to low and build the tonal strength layer over layer, blending across towards the lighter areas.

The other option is through reduction of existing tone. Subtracting works in opposition by reducing an already existing dark layer. Set the eraser to Vine Charcoal. Stroke the area of reduction and adjust the width and opacity settings to the level required. Blend the tone by reducing it against the darker layer. It may help to slightly underestimate the strength of the stroke in order to ultimately have more control over the amount erased.

Using the iPencil to draw tone

Drawing tone is made much easier using the iPencil. It is incredibly sensitive. It simulates how materials handle and achieves an accurate imitation of the 'real' drawing experience. Before the iPencil, styluses had been limited in what they could achieve. The drawback of drawing on the iPad had been the inability to use the tool to make a mark that could imitate an actual drawing and painting experience. When using a pencil or a brush we apply a variety of pressures depending on what kind of mark we need, how much material there is on the brush or pencil and how we feel. This alters the intensity and width. With the iPencil the mark itself can be expressive. It provides more freedom and control than if using a standard stylus or a finger.

Tonal collage with paper

A very effective exercise is to make an actual tonal collage with pre-prepared papers, working from the figure or a drawing. The process of making it with scissors, glue and paper will force you to see, edit and arrange tonal shape and value.

Prepare five different tones of grey on separate sheets of paper. One sheet would be almost but not quite black and one almost but not quite white. One would be a darker

It is useful to consider what the light source is and where it is coming from. The source might be coming from more than one place and it may be a combination of natural and artificial light. Light is unpredictable. We can see what the source is and try to work out roughly what it will do. It will usually do something unexpected. Its reaction depends on the surface and surroundings it is falling upon. Given the variety of human shapes, skin tones, scales and surfaces there is an infinite array of possibilities. Light can appear to be moving directly but once it encounters objects in a room, such as a figure, it can start reflecting and bouncing off surfaces, complicating the view and our idea of what we are seeing.

The tone closest to the light source, the highlights, will result in sharp relief as they are the brightest and lightest area. In the shadowy and shaded areas there will be illumination and reflected light bouncing in. Nothing is so completely black that we cannot see into it and through it. If the darkest darks are too dark they will not suggest air and space moving through them and will make the drawing appear flat.

The darkest parts of a shadow are generally at the points of contact, perhaps where the figure rests on a surface or in the thin long deep spaces between forms resting against each other. The darkest areas will be near to where the shadow gives way to light. To complicate matters, if there are a variety of different light sources there will be overlapping shadows.

This drawing shows the transition of tone across the body through blending. Within the large even tone there are subtle lighter and darker areas blended in to imply depth and suggest the effect of reflected light. The hand leaves a hard-edged cast shadow just below the breast as does the dark tone surrounding the figure.

Five hand-painted sheets of tone from light to dark ready for cutting and tearing to create the collage.

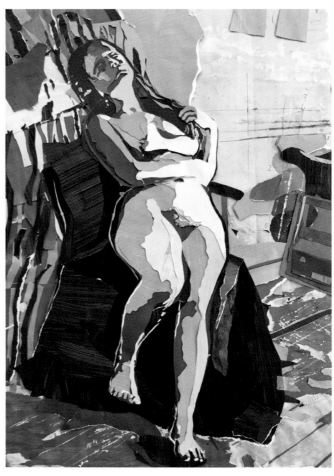

An A1 collaged tonal study made with five acrylic hand-painted pre-pre-pared shades using torn and cut sheets of paper. Two tones are close to, but not quite, black and white and the remaining three are ranged between the two extremes. Even with this limitation, the collage is capable of suggesting deep space.

mid-range grey and the other two lighter mid-range greys. Prepare large sheets in advance and give yourself more toned paper than you think you need. Begin with a basic flat background tone to eradicate the white of the paper itself then build the collage in sections moving from the back towards you.

If it is a seated pose then the chair or couch needs to be included. This can be another tonal layer. Then the figure layer itself sitting on the chair. Is it possible to squint and reduce the whole figure or large sections of it into one aver-age tone? Cut out large shapes to represent this tone so you are almost pasting in a silhouette of the whole figure. Now you can find shapes and tones to sit on top of the larger shape, building the collage over itself. You will need to keep it simple so some tones will have to be amalgamations and approximations; you need to decide which piece of tonal paper is best suited to the particular shade you want to describe. The shape and proportions should be as accurate as possible.

The beauty of this approach is its restrictions. You are literally drawing with scissors and cutting shapes from the paper. Detail within the shapes is subverted as you are focusing on the shape and value. In fact, it is almost like making a sculpture in extremely low relief, building it up from the picture plane towards you.

Additional considerations when drawing in tone

As well as accurately reflecting shape and value there are some key ideas that have to be considered when making a tonal drawing. Become aware of all these key elements, be sensitive to them and implement them into your sustained tonal drawing.

What is a line and what is tone?

Often people will have line and tone in a single drawing with the line outlining the edges of forms. In tonal drawing we are looking for overt and subtle tonal variation in order to describe the distribution of light on the surface. In reality we can see no lines, outlines or linear descriptions on the figure and its surroundings. There may be extremely thin shadows in the gaps between forms that look linear. Lines are a part of a visual language that we accept but does not exist in reality. We have learnt how to read and interpret lines in drawings and we have become used to seeing linear interpretations of solid objects. However, the figure is not made up of lines really.

In a line drawing, we can use the lines to indicate the edges of an arm, a leg, a shadow perhaps. Using tonal value and shape, an edge of a form is now suggested by the

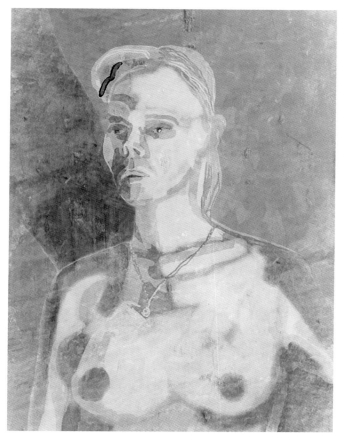

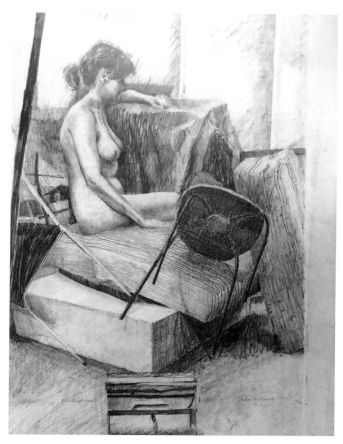

The edge of the figure is not bound by and described by a line. There is often an urge to contain the figure, even in a tonal drawing, in an outline. No such lines exist. One form or plane comes up against another and it is the tonal differences between them that tell us about edges and the distinctions between them. The human figure is not surrounded or bound by a dark line. Some of the tones in the forms and the background in this drawing are very similar. At times, this can make the edges indistinguishable in parts from the background. This is known as lost-and-found edges.

Contextualize the drawing of the figure by including the surroundings.

difference between one tone and another. The figure is a solid object seen and understood through tonal differences existing in space. This implies different surfaces and depths.

Lost-and-found edges

At times the difference in tone between the edge of the figure and the space around it or adjacent sections of the figure will appear to be non-existent. Even though we know what we should be seeing, there are no clear tonal distinctions. We understand what we see as our brains can make up the difference and fill in the gaps for us, but still, the figure will have the appearance of merging into the background. This is known as 'lost-and-found edges'. This effect can be manipulated in the drawing in order to play with the viewer and focus attention on various parts of the composition.

Surroundings, backgrounds and settings

The posing figure can be seen alone or can be set within a context, in a room with or without other figures and props. If not alone, the setting and other elements will enable you to relate the form to its surrounding space and describe how it occupies that space. This could be significant as the pose could be dependent on a prop or an object such as a chair or a cushion. This is an integral part of the pose as the figure is responding to this so its influence needs to be considered and drawn in conjunction with the figure, not as an afterthought. Build it into the drawing, giving it equal status. It may be that in a reclining pose the weight of the figure is absorbed by the soft surface they are lying upon. Or perhaps, if sitting on a harder surface, the pressure of gravity distorts and affects the shape and mass of the figure.

Additionally, the room is a setting that can provide a context for the figure. The setting can be prepared with props and lighting as desired.

Ways of Creating Tone

Any implement that makes a mark is capable of creating tone. If it is not possible to create a flat, even block of tone, with for instance pencil, charcoal or paint then we have to use our tools in different ways. A fine-line writer, biro or ink pen produce solid, single individual lines and blending the marks is not possible. Each of the lines is a decisive one capable of some but limited variation. Even so, by taking a tool that makes rigid, static marks it is still possible to suggest tone without relying on blending. It will depend on how that implement is used and manipulated.

A build-up or accumulation of marks is necessary in order to create an area substantial enough to be read as tonal. Using the marks in their most limited way, without variation in width or tone, it is possible to get impressive results. The basic idea behind the approach is that the wider the spacing between the lines or marks is, the lighter the value is. The closer and denser they are then the darker the value. If the value of the mark made can itself be adjusted then further variation of tone can also be suggested.

With the iPad it is possible to use the brushes within the drawing apps to adjust the opacity of the marks in the same way to suggest variations in pictorial space and create dynamic drawings. The eraser tool will be useful too as a drawing implement. Any brush style in Procreate can be used as the eraser and can draw negative marks back into the drawing in any of the following examples.

It may seem that to use a single broken line repeatedly at a variety of angles would limit the options somewhat.

However, there are a variety of approaches to explore and expanding the idea of using marks to create tone will provide opportunities for development. The method has been used for centuries in traditional printmaking techniques such as etching and engraving and is still popular today.

A distinction needs to be made between line and marks. A line can be used to describe the shape and edges of the figure or related objects. For the purposes of the tonal drawing approaches, repeated lines whether short or long can be grouped together to describe areas of tone in the figure itself. By trying to describe form and volume with tone you should be conscious of the use of, line and its potential to flatten the form if describing outlines and shapes.

Often, when beginning a tonal drawing, there is an urge to make a line drawing of the figure and then drop in the tone or shading afterwards. There are downsides to this approach. Firstly, remember you are actually attempting to make a tonal drawing and the aim is to create an image that suggests depth, solidity and dimension. It has more of a sculptural element than a linear one as it is responding to the effects of light. If your line drawing of the figure is inaccurate the tone will never go in the right place and the whole drawing will be compromised. In such a drawing, the tones within it could be incredibly subtle but as the proportion of the figure is inaccurate so would be the tonal shapes. Build the volume with tone from the outset and actually measure and consider proportion in the process rather than approach the drawing in two parts. Line can and should be

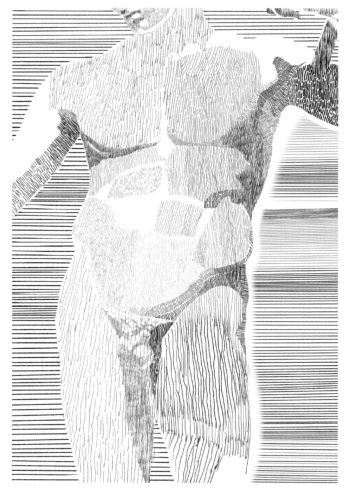

Hatching in line drawing. Drawing long or short lines close together or further apart can create a sense of tone. Closer together the tone will appear darker, or lighter if the lines are further apart. The line itself can also be adjusted tonally to add another tonal dimension.

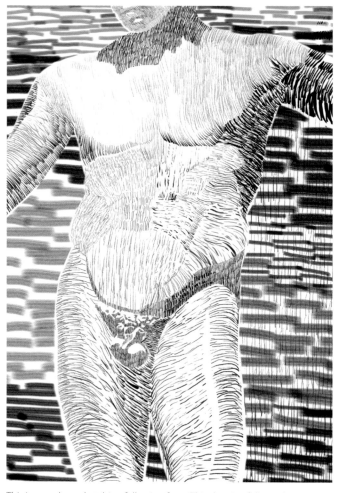

This image shows hatching following form. This drawing follows the same idea as the previous drawing but the lines have greater variety in width and tone as well as brush style. They also follow the contours of the figure more closely, attempting to describe its topography.

used sparingly to provide indications of proportion, placement and angles, even describing tonal shapes. Do not to allow it to dominate and to defuse the three-dimensionality.

HATCHING

Parallel lines closely drawn together can be used to describe tone. The length of the line can vary or remain the same. The closer the lines are to each other the darker the tone will appear. The strength of the line can be adjusted to reflect the depth of the tone required. The wider the gap between the lines, the lighter the tone will appear. The effect can vary from being very controlled and regular to a freer and looser application of the lines.

Use at least two sets of parallel lines with one crossing over the other at a diagonal until the lines pick up depth to the tonal pitch required. The quantity, width, length, angle, strength and spacing of line can be varied in order to manipulate the tone and create contrast. The different tonal areas can be knitted together as they transition from one to another. Avoid building up the marks too much and too closely so they become a dense dark with no suggestion of light at all. Work more subtly, transitioning the tonal values between interconnecting areas of tone and maintain a variety of spacing between the lines.

Curved contour lines can reflect the form. Imagine the figure wearing tight horizontal-striped clothing. The lines themselves are completely parallel in the unworn state with uniform spacing. When worn and pulled over the figure they are distorted as they follow the contours. Even subtle

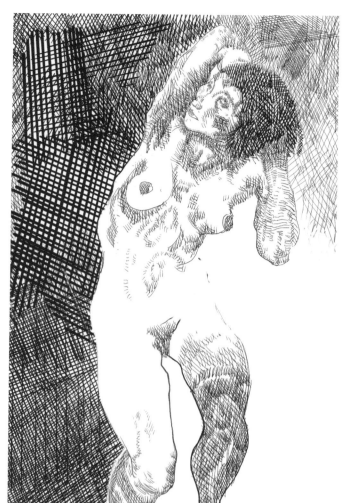

Here we can see cross-hatching. The lines criss-cross over the surface at a variety of angles, weights, widths and spacings. The shadowy background area uses regular ruled lines whereas the hatching in the figure is looser and more random.

This drawing uses long parallel lines to create areas of tone. All the lines are parallel but they vary in their width, tonality and spacing. This makes each area seem flat and two-dimensional but when in juxtaposition recession and depth are suggested by their differences. The thickness and proximity suggest different values, spatial depth and directional lighting. The drawing is carefully designed and controlled, almost mechanical.

This image shows a cross-contour drawing. As in a previous example, the lines follow the contours of the body, trying to describe the form of the figure across the width. The line dips subtly through a shallow undulation and whips round dramatically at the edges. Notice some lines have been drawn as a negative erased mark.

undulations are visible in the journey of the lines across and around the surface. These are the lines that should be visualized and drawn in combination with cross contours to help add shape and depth.

VERTICAL AND HORIZONTAL LINES

By drawing tone, the intention is to suggest volume and space. This exercise encourages the elimination of descriptive lines and outlines and focuses the attention on creating a form in space as soon as the drawing begins. The urge when beginning the drawing, even if it will be tonal, is to use line from the outset in order to plan out the figure. This diverts attention away from the three dimensions. This drawing should focus on the form from the beginning with the challenge of just using vertical and horizontal lines.

The aim is to avoid any form of pre-planning using an outline or a line that is not vertical or horizontal. The intention is to avoid linear descriptions as this can easily dominate and compromise the tonal approach. Avoid the temptation to make a line drawing that will be filled with the lines to create the tones. It might be helpful to identify

These are in-process drawings for the vertical-and-horizontal-line-only drawing. The eraser is useful in this drawing as it can correct and contribute to the effect. It can be set to the same brush style as the drawing tool itself.

A steady build-up of vertical and horizontal lines can describe tonal areas and the details within them very accurately. The effect can feel rather ghostly. This exercise is designed to rid the drawing of an outline that will be 'filled in' with tone. The point is to begin responding to light and its effect at the beginning of the drawing and reflect that as soon as possible. Cursory planning can be applied but decisions about proportion can be made in the process. Areas of tone can be pre-prepared with a general layer of light verticals and horizontals to break the white surface of the paper.

basic tonal areas and to mark these out faintly using line. This faint preparatory underdrawing will be overpowered eventually.

From the outset, tonal shapes and values need to be identified and inter-related to describe consistent movement across the form. Build up the lines slowly and carefully without going in too dark to begin with. It may help to cover the drawing surface with a light thin layer of horizontal and vertical lines at the outset to break the imposing white surface and to provide an immediate space for engagement.

If the lines over-mass and begin to look like a flat dark area without light, use the eraser tool on the same brush setting as the line tool to draw back into the image and adjust the value and spacing as needed. The ability to use the eraser to cut back into the drawing and adjust the tonality and frequency of the marks really helps the delicate tonal balance of the drawing.

SCRIBBLING

Building up layers of random linear scribbles will eventually create tones. As the spacing between the scribbled lines becomes tighter they start reading as a block of tone. With care they can be made to look flat and even, as well as having tonal variation. Tonal variation can be suggested by increasing or decreasing the intensity and frequency of the layers or overlaps. These drawings were made in this way. Rather than having one tonal area flowing into another,

Scribbling can create tonal areas. Each of the elements in this drawing has been made using scribbles. By varying their density and spacing, tone can be created and adjusted to describe the variations of light moving across the figure. The width of the lines is fairly consistent throughout the drawing but the weight of them, and so their tone, varies from section to section. Each part was edited into shape using the eraser and then arranged into the composition.

Here we can see stippling or dotting. Dots, like lines, when repeated and placed close together will create a mass of tone. The beauty with this approach is the light it can generate as the mass is not solid. Very subtle variations and great detail can be achieved with this method, although it is time-consuming.

attention was paid to the arrangement of the tonal shapes and their edges. Each tonal area was cropped and put into place like a collage would be with paper.

STIPPLING

Stippling is a technique to create shading using dots. The denser the dots, the darker the tone will appear. The further spread out the dots, the lighter the tone. Variations in the size and tonal intensity of the dots will also have a bearing on how the dots are read spatially. That is, would they appear to be deep in the drawing or moving nearer to the surface?

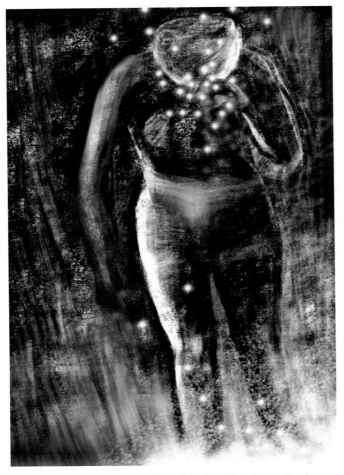

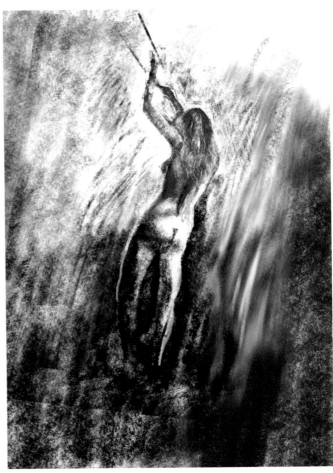

In the following three drawings a layer of the Burnt Tree charcoal brush (Procreate) was laid down as a complete background. The layer was not totally black or totally solid. The drawing was then lifted out of the darkness using the equivalent brush in the eraser setting whilst attempting to avoid drawing back in and redefining with positive dark marks. The eraser was adjusted throughout the drawing to vary the intensity of the rubbed-out elements. By adjusting the opacity setting of the erase brush it is possible to vary the strength of tone removed. In these three cases the setting was already fairly low so, just as you might with a real eraser, repeated marks gently lifted out the tone to the appropriate strength.

The size of the eraser varies substantially in this drawing from wide flashes of whiteness at the top right-hand side to the fine detail in the hair. The smudge tool was also used to the right of the figure. The smudge tool can be used for blending one colour or tone into another. Adjust the brush style and the opacity for different effects. It may be difficult and unpredictable to control but with practice smooth transitions can be achieved.

ERASING

These drawings were made using the Burnt Tree and Charcoal Block brush options as positive and negative erased marks. A dark ground was laid out in widths across the whole surface to begin with, like a piece of charcoal on its side across the paper. The strokes were kept dark exploiting the irregular broken depth of tone of the mark and yet attempting to maintain the suggestion of light within and behind, avoiding a dense flat blackness that would kill the surface with its flat density. The eraser was set to the same brush setting. The aim of the drawing was to avoid reworking the image with the addition of further darks. The challenge was to create a drawing that showed energy and vitality with the restriction of using the eraser as the only drawing tool by eroding away at the dark surface, describing the figure, finding subtle gradations of tone. If a serious drawing error occurred in the erasing process the charcoal was reapplied to the particular spot and erasing was begun again.

Most of the background tone has been eradicated, just leaving traces. The Procreate blur tool has been used in the lower sections of this drawing.

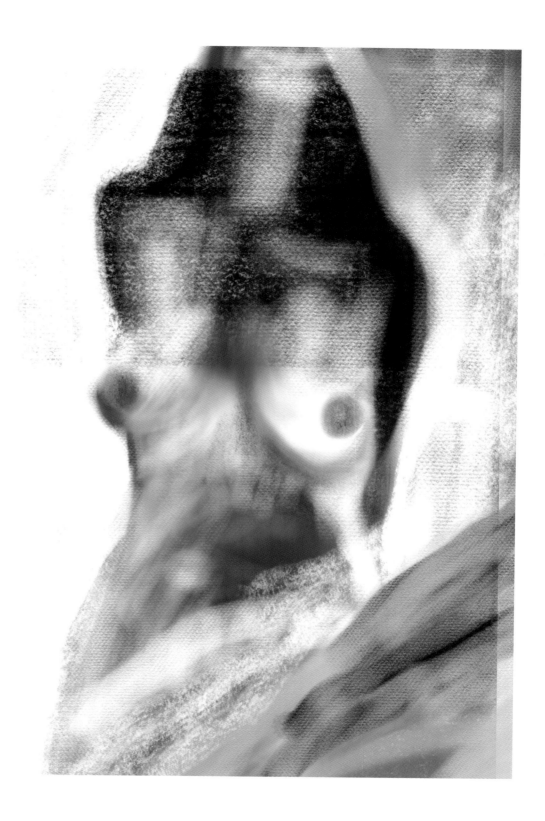

Line

Line

Line

Line

Line

Line

Line

Line

Draw lines, young man, draw lines; whether from memory or after nature. Then you will be a good artist.[15]

JEAN-AUGUSTE-DOMINIQUE INGRES TO EDGAR DEGAS

MAKING LINES

Lines can be used to describe different aspects of what we are seeing. In Chapter 4, line was used to show how light and shade can be created through the use of hatching. Line can also describe texture, shape and contour. Line itself does not exist in the real world. Figures are not made from lines. They are solid forms. Knowing how we can use line, how it works, will help you communicate your ideas in your drawings effectively.

Many variables will affect the quality of your line. Lines have different qualities because they can be made in so many ways. All drawing implements have their particular characteristics and each will have a variation of these. The surface the tool is applied to will have its own influence too. A rough surface will affect the same material in a different way to a smooth surface.

How is the line being made? How is the tool being held? What effect do the pressure and angle have? Does the line have an urgent energy about it or was it made carefully and considerately? These elements combined will elicit a vast variety of results. With practice and experience you will be able to control your lines, to a point, and use that to your advantage.

Drawing on the iPad screen is not the same as using a drawing tool or brush on paper or canvas. As discussed in the Chapter 1 the iPad tool will have a considerable bearing on the resulting marks. The stylus is the point of contact with the surface of the iPad and the closer it can emulate the subtle action of a pen, brush or drawing implement the better. A regular stylus can only go so far and again the iPencil is the closest we can get to the ideal.

EXPLORING LINE: DRAWING AND PAINTING BRUSH QUALITIES

The more sophisticated apps should allow you to adjust the qualities of the brush itself and even add your own brush designs. Procreate and Brushes Redux have many options available for adjusting the brushes which are easy to access. Additional brushes in Adobe Sketch can be imported from Adobe Capture, the Creative Cloud and other sources such as Dropbox and iCloud Drive.

All the brush styles can be adapted in a number of ways. Find the options in Procreate by tapping on your blue high-lighted brush. A new window of sliders will open up. There are categories to select from such as stroke, shape, grain and dynamics. Spacing, streamline and jitter are choices available to change the stroke of the mark. Stroke tapering can also be altered and this might be beneficial in particular if you do not have a Bluetooth pressure-sensitive stylus. Some of the effects may be similar to an existing brush style. Sometimes the changes may be negligible, with the effect varying its intensity from tool to tool. Experimenting is the best way to find what can be done.

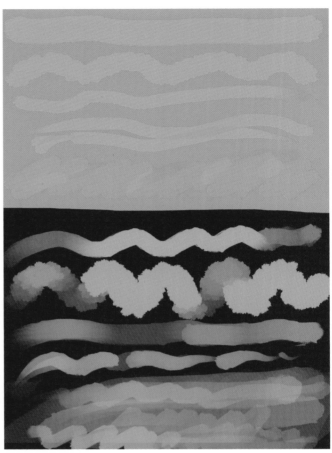

Here we are exploring line qualities. The following three images show the effect on the drawn mark when the settings have been altered. Each image is in two halves. The upper half shows marks using a non-pressure-sensitive stylus and the lower half using an iPencil. Each half has five examples. At the top of each half is the unmodified stroke at its default setting. The second has had the jitter slider increased. The third mark has the taper sliders on full. The fourth is as the third with the size slider included and on maximum. The final is the default setting again using the tool on its side or edge. These are just a few of the options available. The brush in this example is the Gel Pen from the inking folder. All three choices are from Procreate.

The lines made using the basic stylus are of the same intensity. They do not vary. Changes in their tonality would have to be made by the app's on-screen opacity slider and not the tools adjustment options. The taper slider has had an effect and the line does have tapering at the beginning of the fourth example. Using the stylus on its side has no effect on the mark.

The iPencil lines are responding to pressure. The more pressure on the surface, the thinner the lines made, varying their width quite dramatically in the case of the jitter option.

Even though the Round Brush in the painting folder is designed to operate as a brush it can still be considered as and used as a line.

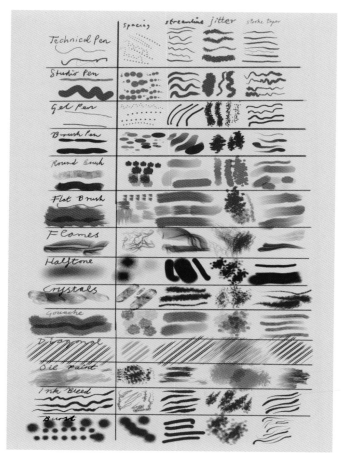

This series was made using the Soft Pastel brush in the sketching folder. The standard stylus option follows the same pattern as previously. The iPencil version illustrates how pressure and its variations play such a significant role in the mark. The line has a depth and variety that can be used with sensitivity. Not only is the line changing its widths but also its tonality and transparency.

This chart takes some of the Procreate brush options and explores the effects of changing the settings. In this case, the spacing, streamline, jitter and stroke taper have been adjusted.

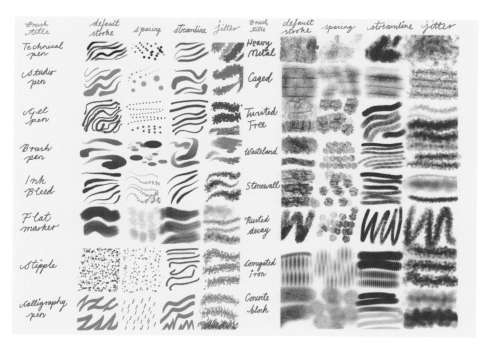

Another chart with different brush choices. In some cases the changes are negligible.

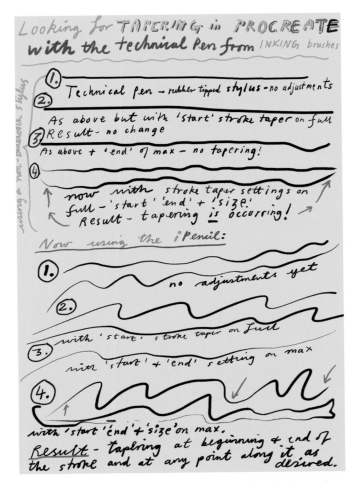

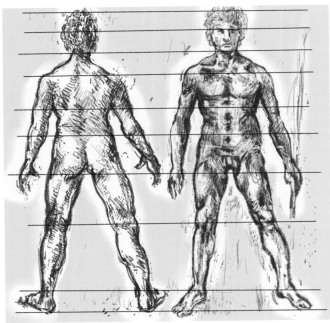

This is a copy of Leonardo da Vinci's 'A Standing Male Nude', front and back views, in the Royal Collection. It illustrates the horizontal lines between relative points on either side of the body when seen from a head-on viewpoint.

Having a good degree of control over your drawing tool and understanding its capabilities are crucial when drawing. Tapering a line shows an intentional variation in application of pressure and sensitivity in response to what is being observed.

USING DIAGONAL LINES TO UNDERSTAND THE POSE

As part of the planning and understanding of the visual relationships in the figure look for linear rhythms running through and across the body. Imagine a linking line across the two shoulders. In a head-on standing pose this line will be horizontal in your drawing as the shoulders are on the same level. Similarly, the lines across the eyes, hips, knees and feet will be horizontal too and they will all be parallel to each other. Change the pose and all the relationships change. The horizontals become diagonal with some in the same diagonal and others now being completely different.

Summarize the pose in five or six straight lines, either visually or into the drawing. If you had to build a basic armature for a sculpture based on the pose what three of four lines would describe the overall shape? Poses often can be reduced to a few diagonals that encapsulate the diagonal pattern. The shape of the lines could be described as being triangular or scissor-like, for example.

Repeating diagonals are visual lines, not drawn lines, but they can be drawn in if they help make the drawing easier. They are linear rhythms and associations through the pose that provide structural understanding about the arrangement of the figure. Often a pose will have a series of repeating diagonals through it. Use your pen or drawing implement to help you see them. Some of these may be long, others may be very short, perhaps just the side of the neck or the foot. Align the edge of the pen against a diagonal created between two points and range it over the pose, latching on to any similar or recurring angles. This is a part of the process of seeing and understanding what is going on across the whole figure and will provide useful discoveries and information regarding the balance, rhythm and movement in the pose. Once identified, the drawing should aim to reflect these discoveries.

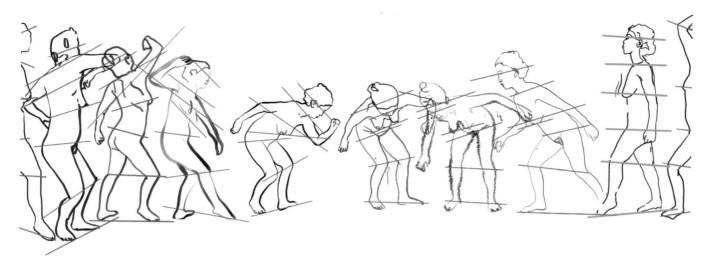

The model is twisting and turning. The principal angles across the eyes, shoulders, breasts, hips, knees and toes have been highlighted with the red line. As seen in the previous drawing, from a head-on standing pose they would all have been parallel. As the figure moves from right to left, twisting and turning as she goes, all the diagonals change, not just from pose to pose but also within each pose, relative to each other.

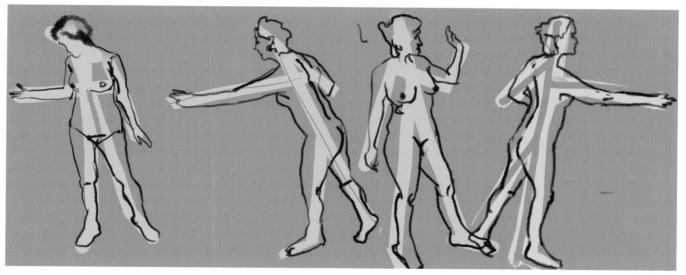

Reduce the pose to three or four essential lines to summarize its structure.

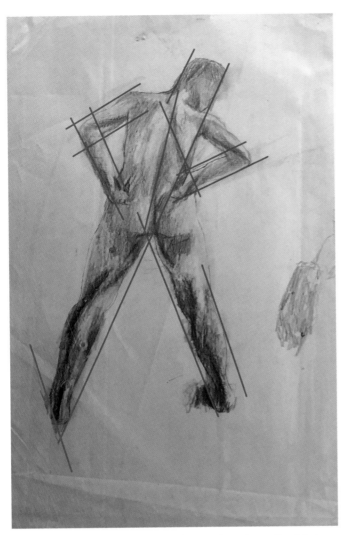

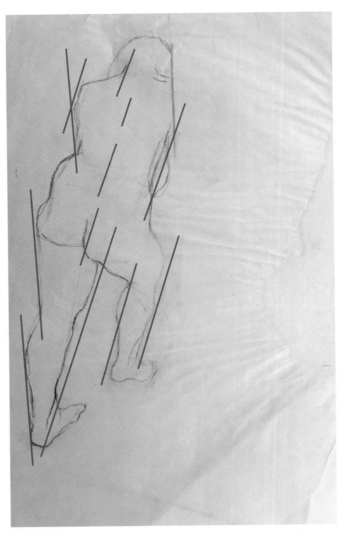

Two clear, long diagonals make this an almost x-shaped pose. The right leg is in the same line, but slightly offset, as is the lower part of the left arm. The left foot echoes and parallels this angle.

This model is actually leaning on a wall, indicated by a short vertical line at the right shoulder. The lines running through along the side of the legs, the body, parts of the arms, the backbone and the line of the head are in parallel with each other.

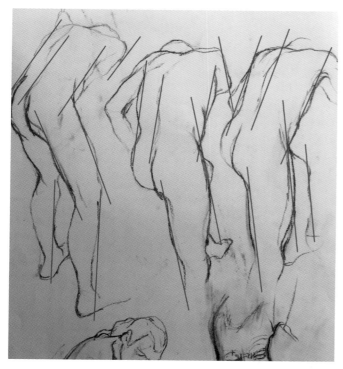

The three poses are more or less the same. We can see a simple zig-zag arrangement up through the lower legs, the thighs and the torso.

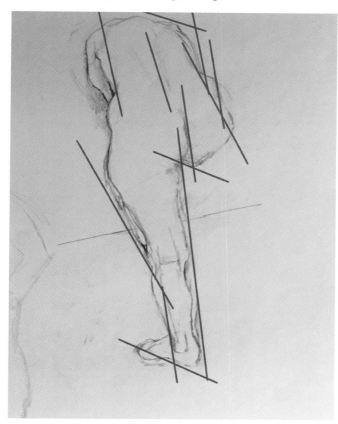

The model is bending forwards and leaning the right foot on a hidden support. Notice a parallel relationship across the shoulders, a tiny part of the lower right buttock and the left foot.

A series of rapid poses with differing line qualities. In a number of these the eraser tool has been used as a linear implement to draw through the figure, reinforcing the rhythms.

CAPTURING THE FIGURE IN LINE

Just a line? With a single line we can express grandeur, nobility, sensuality. The single line synthesizes sensations and concentrates knowledge.[16]

RENÉ GRUAU

Rapid poses

Short poses allow models to stretch themselves and exploit more demanding configurations. A short pose can be from a few seconds to several minutes. A ten-minute pose may feel too long if your drawing is a quick gesture study. It is all relative to your intention. The length of pose will allow you to pursue certain ideas. In a pose of a few seconds there will only be time to get a sense of the shape and the rhythm, using a few lines, striving for balance and unity. A ten-minute pose will provide plenty of time to get a good sense of the whole, build the structure accurately, work on the proportion and include some details.

A figure in a standing pose should appear balanced. The vertical line down from the head will be the centre of balance. Often this line will be over the weight-bearing leg but not always. The line should fall somewhere between the two feet in order to prevent the figure from appearing to be off-balance and potentially falling over.

Balance and unity

Have an awareness that we are symmetrical structures and the moment we move we are changing weight, balance and axis[17]

BRIDGET RILEY

What forces are at work within the figure? Where is the weight and the pull? What is preventing the figure from falling over?

The body controls itself in response to gravity. If the pose is freestanding, the body has to maintain its equilibrium. In order to maintain balance one movement is opposed to another. If the figure leans out of balance there will be evidence of counterbalance. If you lean over to your left with your left arm pointing out, something will have to counterbalance you on the opposite side or else you will fall over.

In a standing pose, look for the balance point running down from the pit of the neck to the weight-bearing leg. Mark in the balance line and the position of the weight-bearing foot. The pencil intersects the ground at the point where the weight falls. What is the relationship between these two points? If the model supports themselves in some way, by leaning on a chair for instance, the centre of balance will shift.

Gesture drawing

The figure is always gesturing. It is the characteristic of any pose. Capturing the essential gesture is the challenge. Look for the most obvious visual shapes and the relationships between them. Let the stylus flow over the whole rapidly. Be spontaneous, reacting with bold confident marks. By focusing on the whole figure and not the detail there is a better chance of creating a unified drawing. Be aware of the time constraints and work right up to them, changing anything you feel is not working well. Focus your attention on the figure itself and occasionally glance at your drawing. As you run out of time you will be forced to make quick unplanned decisions. Look for shapes linking across the complete figure. Think about how the eye moves over and sees the form; do not focus on accuracy at the expense of the whole. To a certain degree, accurate proportion can be overlooked in favour of a successful drawing that defines its intention. Work your lines in and through the subject. Do not focus on it as a silhouette or outline. Lines move inside the body, forms overlap, muscles have edges that appear and disappear out of nowhere or in conjunction with other

Quick poses will demonstrate aspects not achievable in a longer, more relaxed pose. You can have a combination of elements acting upon the body at the same time. These may include stretching, pulling, dangling, twisting, balancing and moving. This will provide dynamic possibilities with varying degrees of tension and stress across the body which can only be held for a few minutes.

Rapid responses against the clock are needed in order to provoke a reaction in the drawer. Too much drawing time would indulge your thinking and planning mind. Take the basic ideas from the measured drawing approaches. These can be applied extremely quickly to the rapid poses. Width and height are the immediate concerns and some indicators can be put down swiftly as a guide. These drawings can be seen as warm-up exercises for more sustained work.

For Goya drawing was an instrument of freedom. Only very rarely do you see him practising poses or expressions from the earlier repertoire of other artists. He knew, better than most painters of his time, that recipes contain no guarantee of success: everything depended on that first coup d'œil, the first moment of intersection between the real motif and the hovering, undecided nib or brush point, and without spontaneity that encounter could well be lost.[18]

ROBERT HUGHES

Many drawings will contain parts that have been less successful than others. Get used to taking chances. Avoid being over-precious with the drawing to the extent that it inhibits how you work. The iPad and the apps offer you the chance to select from a wide range of lines and an unlimited supply of surfaces. Be selective and get used to a few tools as you build up the sense of working on the screen. Do not overcomplicate your approach. Try things out and react spontaneously. See what happens. Keep all your drawings and review them at a later time. Contained within these drawings are the clues to your creative development.

forms. Look for the shape of shadows and the shape of lights, lines snaking their way up and across the body, connecting all of its parts into a complete whole.

Contour lines

A line cannot exist alone; it always brings a companion along. Do remember that one line does nothing; it is only in relation to another that it creates volume.[19]

HENRI MATISSE

Lines can be used in distinctive ways to suggest particular visual effects in the drawing. An even line without variation can make the drawing appear flat and without depth. Varying the width of the line can allude to the form occupying a three-dimensional space. Tonal changes in the line may allude to the direction and impact of light hitting the surface of the figure. Cross-contour lines define the edges of the figure, as the contours across the form illustrate the undulations caused by muscle and the skeleton. Use the myriad of options available to you to change your line quality to see what is achievable.

This drawing was made in response to Egon Schiele's 'Nude Leaning to the Right' from 1918. The line flows across the figure, describing the contours. The line in parts is tapering. By varying the width of the line some points will jump out of the drawing and attract attention whilst the less prominent lines will drop further in. Look how the edges of contours appear and then disappear, overlapped by contours that are depicting the foreshortening of the muscle moving up through the thigh towards the knee. Variation of line width over the contour can suggest volume in the figure. Lines showing overlapping forms will also be interpreted as the figure occupying a space and the suggestion is of moving across it into that space.

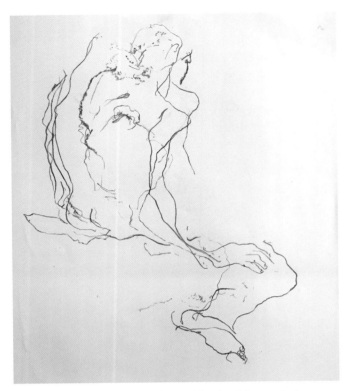

This is an A1 blind contour pencil drawing. The aim of the exercise is to improve hand eye co-ordination. You will arrive at a record of what your eyes have seen. Without looking at the drawing itself, you will be disinclined to correct the drawing based on how good or bad it appears. The idea is to encourage you to focus more on the looking rather than what is going on on the drawing surface. The drawing is made very slowly, with as much detail as possible, reflecting the journey of the eye across the whole figure. Every bump, dip and visible detail is recorded. The line quality, if made sensitively and unconsciously, can be particularly varied, reflecting the hesitations and doubts in its attempts to depict hair in its varying forms, the long edge of a limb or the detail of an eye, for instance.

As we have already seen in Ways of Making Tone lines can be used to describe the form of the figure. Cross-contour lines aim to describe the journey over the figure through and across the forms. A tattoo on the skin is following the same form in selected areas. A tattoo poses great challenges as not only is it following the form of the figure but it is also a depiction often with just line. The tattoo in this illustration is a geometric pattern wrapping itself around the forearm of the figure.

Experimenting with lack of control

There are a number of well-established line exercises designed to challenge you that should be tried. They are blind-contour drawing, continuous-line drawing and partial-peek drawing. Try these with your drawing hand and with your non-drawing hand. They will sharpen up your observational skills. If you are working alone, you will have to be very strict with yourself in order to stick with the exercises. Do them effectively because they can be very enlightening. Not only will you observe the figure differently, but with some of them in particular the mark-making possibilities can be revealing.

With blind contour, draw without looking at your drawing and focus solely on the figure without corrections. Time is spent looking at the figure and following the information within it. The hand reflects where the eye has been and records that journey. This can produce a highly sensitive response from the hand with subtle and profound variations across the line reflecting the progress of the eye. Clearly the drawing itself might look incomprehensible but the point of it is to move slowly across the form and reflect that.

Try making a line drawing without corrections. Challenge yourself by not allowing any adjustments with the eraser tool. The aim is to complete a drawing that shows detail and accurate proportion to a convincing degree. This is difficult to achieve as each mark should be seen as permanent and the task is to move forwards. This drawing should not be considered a continuous line drawing. It is a drawing that cross-references itself in real time and might have to be abandoned if any mistakes cannot be successfully amalgamated. The aim with a mistake would be to

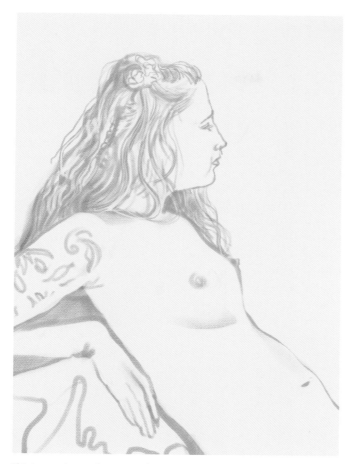

This image shows a long pose, drawn slowly with a consistent line.

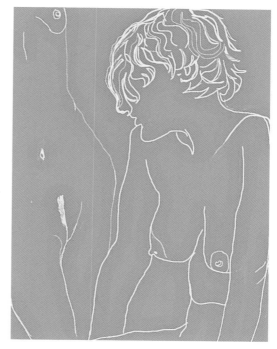

Here we have a line drawing made with restrictions. The trick is to try not to erase or correct the drawing and complete it in a short timed sitting of two minutes.

manage it into the drawing before it becomes too obvious. An empirical vision of the whole drawing is required at every stage in order to know where it is going and what needs to be done. Remaining in scale in relation to what has gone before and plotting the future course of the drawing will build your skill in scanning and planning information.

Consistent line drawing

Hockney's pure line drawings are astonishing productions. Here every stroke is on its pins, ink forbidding error. No corrective back tracking. No anticipatory roughing out. It is like the hoop and the electric wire. It is fatal to rush, equally fatal to hesitate, until the end. These drawings are watchable from moment to moment, as lines track their way round each representational problem without losing sight of the whole emerging picture. If there's a case for drawing here, it's drawings like these that must be the leading exhibits.[20]

TOM LUBBOCK

Line quality does not need to be so changeable. Select a tool that gives a more consistently even line, the equivalent of a fine-line writer. Like the Hockney rapidograph drawings from the mid- to late 1960s, create drawings that are still and detailed, that exude care and precision. They should be attempted in one intense, focused sitting, capturing the characteristic detail and poise of the model. Ink drawings on paper allow no room for error as they cannot not be corrected and so the tension and ambition of that restraint comes through in the drawing. Take the line, limit your options and challenge your skill and self, aiming at and discovering solutions to problems of visual representation in real time, without planning.

Colour and Colour Contrast

Yellow can express happiness and then again pain. There is flame red, blood red and rose red. There is silver blue, sky blue and thunder blue. Every colour harbours its own soul, delighting or disgusting or stimulating one.[21]

EMILE NOLDE

We notice colour and we delight in it. It can move, soothe, calm, reassure and alert us. Colour can trigger our thoughts, feelings and moods. It can be naturalistic, expressive, symbolic. We can feel warm or cold because of it. We respond emotionally to colour.

The advantage of working with colour on the iPad is that you do not have to mix any paint to find the colour you require. You might need to make some adjustments in tone and intensity, but the colour is there waiting, somewhere in the colour palette, ready to be identified and picked. This is useful and easier than mixing from scratch but real experience of colour mixing is valuable. The benefit of actually having to select and mix colour from tubes is that you will almost always get it wrong to begin with. With experience you will be able to recognize colour more easily and know how it has been created. It is the process of selecting the combination of colours and judging their intensity, quantity and tone that forces learning. Mixing colour and seeing what colour can do through use will provide a valuable insight. So, it would be very beneficial to undertake a series of practical colour studies to underpin colour behaviour, understanding and application.

Even using the iPad there will be an element of trial and error and that itself will be helpful. You have instant freedom and control to try out any colour in the painting to see how it fits. If it does not work it can be adjusted easily, or rejected. With the undo button or the layering option the colour choices can be manipulated. That level of changeability is not as easily possible in real painting. The iPad makes it extremely easy and the variations available feel infinite.

DESCRIBING COLOUR

In order to use colour in a powerful way, a general understanding of how it works is necessary. The best way to understand colour is through observation and use. Knowing something about how it can behave will help enormously as you will be able to use it to your advantage. A working knowledge of the colour wheel will prove advantageous for your awareness of basic relationships.

When we choose colour in the app we will be shown a colour wheel to make selections from. The wheel is a visual representation of the relationship between colours. The wheel you use with the app will have the colours transitioning around it so they merge smoothly. The three primaries on the colour wheel are red, yellow and blue and these are spaced equally. As you follow the circle around you can see the transition and effect of mixing one colour to the next. The journey from the primary red to the primary yellow will be red-orange, secondary orange, yellow-orange and then yellow. The yellow will continue towards blue and change through the green hues. The blue in turn transitions to purple and back to red. The secondary colours are orange, green and purple.

The Procreate colour palette as seen as a close-up screenshot.

This is a screenshot of the Procreate colour palette set to the lighter interface. The wheel shows the equally spaced primaries, the secondary colours between the primaries and the tertiaries between the primaries and the secondaries.

Primary colours are unique. You cannot make a primary colour by mixing other colours. However, by mixing the primary colours in different amounts we should be able to find any other colour. In practice, using paint, it is not so simple. Using the iPad, all colours are available without mixing. It is unlikely you will find the required colour to begin with. Adjustments will have to be made in value and intensity and some trial and error will be required.

The colours between the primaries and the secondaries are known as tertiary colours or intermediate colours. These are a mix of a primary and a secondary. They are red-orange, yellow-orange, blue-green, yellow-green, blue-purple, red-purple.

When using and describing colour we should consider three important elements. Firstly, what is the colour name or hue? Is it a blue or an orange or a yellow? What is its value or tone, is it light or dark? Lastly, what is the colour chroma or saturation? How strong and intense is the colour within it? Pure colours like cadmium red and cadmium yellow are intense and strong. They cannot be any more saturated or get more colourful.

COLOUR AND RELATIVITY

In visual perception a colour is almost never seen as it really is – as it physically is. This fact makes colour the most relative medium in art. In order to use colour effectively it is necessary to recognize that colour deceives continually.[22]

JOSEF ALBERS

Colours do not exist and should not be regarded in isolation. They are affected by their neighbouring colours. Colours placed next to each other will be enhanced or diminished by their neighbour. By having an understanding of colour behaviour and exploiting colour contrasts you have more control over your painting and what you can make it do.

Simultaneous contrast

Colours just through proximity affect each other and in a different context appear to have changed. The intensity of the colour is relative to the other colours around it. A bright green will react intensely if placed next to a saturated red. The same green in a field of yellow would not carry equal intensity. The colours themselves do not change.

This image demonstrates the effect of simultaneous contrast. The different background colours and their effect on our perception of colour make it look as if the colours of the figure are different. The figure on the right appears lighter against the darker background. Both the figures are in fact identical colours.

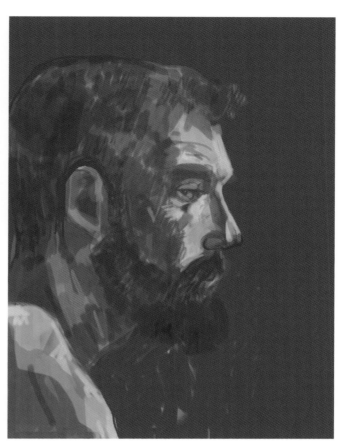

This drawing is made up predominantly of warm colours but there is a hint of blue in the mix. Some of the reds are nearer purple and lilac. The yellows are moving towards green in parts.

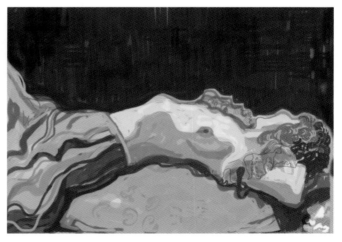

In a similar way, but in reverse, this head and shoulder drawing is predominantly a cooler palette with evidence of warmth. The pinks jump out tonally and some of the deep blues have tinges of red in the mix, making them appear like alizarin crimson.

Here we see a reclining nude using a predominantly cool palette. The figure stretches out on a soft patterned surface staring out into a dark, featureless space. The tonality and colour suggest a night-time setting. Blue shadows run horizontally across the figure with perhaps evidence of moonlight as seen in the pale yellow highlight catching the upper parts of the body, the profile of the face and the elbow.

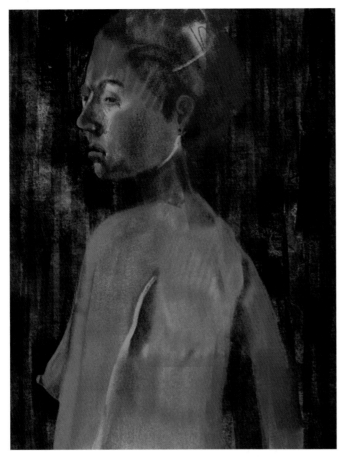

This image uses contrasting near complementaries, brown and blue. The same blue recedes into the background at various points whilst simultaneously sitting closer to the surface layer as light striking the face. The concept of the 'push and pull' of colour and the suggestion of pictorial space was proposed by Hans Hofmann. He believed that artists should remain faithful to the flat surface of the painting and exploit the contrast of colour, form and texture to create space and movement.

Colour is the utterly indispensable means for realizing the various species of pictorial space. Mere perspectival drawing, mere chiaroscuro monochromatic tone – these may render illusionist verisimilitude of reality: but it is a dead version; they cannot produce that fully created thing, found nowhere else, not even in photographs, which I call pictorial space. The imaginative, intuitive re-creation of form which, for years, I have been trying to pin down in a definition is only conceivable in terms of a vibrant picture surface. And this vibration is colour. Pictorial space... is an illusion of depth behind the canvas. It may also be a projection – of plane or mass – apparently in front of the canvas. But the existence of pictorial space implies the partial obliteration of the canvas's surface from our consciousness. This is the role of colour: to push back or bring forward the required section of the design. The advance or recession of different colours in juxtaposition is a physical property of colour: it is a physical impossibility to paint shapes on a surface, using different colours in a variety of tones, and avoid the illusion of recession of parts of that surface.[23]

PATRICK HERON

Exploiting colour contrasts

All colours as seen on the screen are backlit. As a result they glow because they are illuminated. In the dark this is obviously much more apparent. This enables colour on the screen to have a particular power it might not possess in paint as paint itself is not light. The difference between

Consider the contrast of warm and cool colours. We can easily say red is hot and blue is cold. A warm colour next to an even warmer one will appear to recede as in contrast it is cooler. The difference between the two will show the colour temperatures. The colour wheel can be divided into two equal parts with one side containing warmer colours and the other cooler colours. On the warm side would be red, yellow and orange and the cool side would have blue, green and violet. Within each of these two general distinctions there are warmer and cooler versions of the same hue. Ultramarine blue and cobalt blue are warmer blues as they are closer to red than the cooler blues such as phthalo and indigo. Lemon yellow is cooler than cadmium yellow as it has a hint of blue in it.

the screen image and the printed equivalent can at times be a little disappointing. The printed image may feel dull and flat in comparison to the screen version. Paper has its own qualities but backlighting is not one. However, colour on paper or canvas, if used in the right way, can appear illuminated. It is a matter of knowing how to use the colour, whether it is in response to the surface or with the surrounding colours.

Johannes Itten (1888–1967) was a Swiss painter, designer and teacher. He claimed there are seven types of colour contrast. An awareness and understanding of these will provide a basic idea of colour behaviour, which can be usefully exploited as an element through experimentation. *The Elements of Color*, published in 1970, is a treatise based on Itten's book, *The Art of Color*. As we have already seen one type of contrast is that between warm and cool colour. The other kinds of colour contrast are contrast of hue, light/dark contrast, complementary contrast, simultaneous contrast, contrast of saturation and contrast of extension or of proportion.

Complementary contrast

Complementary colours are opposite each other on the colour wheel. The complement of a primary colour is the mixture of the other two primaries. The basic pairs are red and green, blue and orange and yellow and purple. If you work with a complementary pair the colours can affect each other dramatically. When used at full saturation, the contrast is intense.

Apart from the dramatic and intense reaction complementaries can have on each other, the remarkable fact is that when they are mixed together they cancel each other out. They actually destroy each other, to a certain extent. They will produce, when mixed in the right quantity, what is known as achromatic grey. Mixing complementaries is the same as mixing primaries because any two complementaries include all three primaries. The theory is that if you mix all colours together you will arrive at black.

A key colour-mixing exercise is the mixing of complementary pairs. The aim of this exercise is to attempt to discover the grey range. If you plot the journey towards that aim then what you will discover is an incredible array of very useful colour mixes. For each pair of colour opposites that you choose you will achieve a set of new colour variables that can and will inform your ideas about colour mixing. Some of the greys elicited will appear to be neutral but when compared to each other you will notice their differences. On a simple level you may be able to describe

These are complementary contrast acrylic painted studies. They demonstrate the effect of complementary colour mixing. Starting at the left with the primary and secondary pair, the darker colour is added to the lighter in tiny increments so as not to overpower it. Each mix is laid out in a stripe. At a given point in the mix white is added to a band in increasing quantities to show the subtleties of the colour more clearly. This is demonstrated as a series of squares running down the bands, becoming lighter as the tint increases. Notice the neutralizing effect of the mixes and the range of greys that reflect their initial pairs. This exercise indicates what is possible. It can be done with any combination of complementaries. It demonstrates an alternative way to desaturate colour without using black.

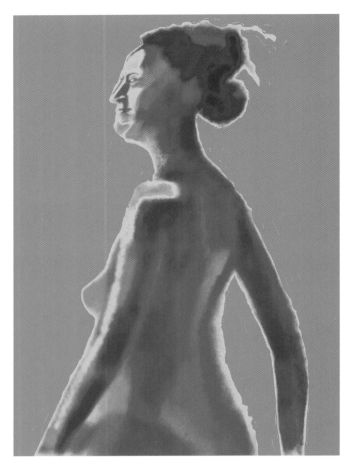

COLOUR CONTRAST HISTORY

Developing colour theories in the nineteenth century encouraged artists to explore colour combinations. The Impressionists sought to depict shadows by using the complementary of the colour of the light they saw. For instance, an orange light would produce a blue shadow. Charles Blanc in his *Grammar of the Visual Arts* wrote about colour in 1884 and his theories had an impact on Van Gogh. 'The starker their opposition – the closer their proximity, the brighter their tone – the more violent struggle, the more intense the contrast. Blue never looked bluer than when set next to orange; red never looked redder than next to green; yellow never yellower than when opposed to violet.' At their most vivid, Blanc warned, these juxtapositions could heighten the contrast 'to such a violent intensity that the human eye can hardly bear the sight of it.'[24]

The colour theories and subsequent explorations were a significant part of not just Impressionism but Post-Impressionism and Fauvism. The fresh approaches to colour use and its effect had a considerable influence on the development of art through the twentieth century.

This image shows contrast of saturation. The colours used in this painting are bright and strong. They are about as saturated as they can be. They are close to being pure colour unmodified by the addition of other colours, black, white or grey and so have an intense luminosity. Primary colours are pure colours that cannot be made by mixing. Once their colours are combined through mixing them together, their intensity begins to be diminished.

them as blue-grey, yellow-grey or brown-grey depending on their root.

Note that thus far we have been considering a primary and its opposite secondary as a complementary pair. You can pick any spot on the colour wheel and select its opposite as the basis for this exercise. There are variables within the primaries themselves. Cadmium yellow and lemon yellow would yield different responses when mixed with the same purple. Cadmium red and alizarin crimson similarly, when mixed with a green. A mixed green can have an astounding number of variables because the selection of blues and yellows available to create it is so wide. Cobalt, ultramarine and manganese blue will all produce different greens when combined with the same yellow, be it cadmium, Indian or lemon yellow, for example.

By taking the complementaries as a starting point and mixing in a variety of quantities we have the ability to mix an infinite array of colours. These are the colours, generally, that surround us in the real world. We do not live surrounded by saturated colours, at least not in the UK. The colour that surrounds us is predominantly unsaturated. Travel further south and colour starts to get stronger as the light becomes clearer and more intense. Look at the colour differences in the early palettes of Matisse and Van Gogh when they were based in the north of France and Holland and their later work after they had relocated to Southern France. Intense colour became a key element in their later work because of the move to the illuminated south.

Knowing how to mix these colours will enable you to recognize them and locate them in the colour palette more easily. The colour in the figure will be dependent on a number of circumstances. Expect intense and saturated colour in combination with desaturated areas.

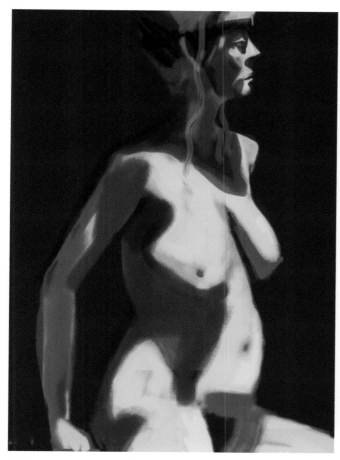

This image shows contrast of value. It demonstrates tone and value in colour. Clearly there is a strong tonal contrast between the highlights and the shadow. Notice that the tone in the arm and around the neck are mid-range, somewhere between the two extremes.

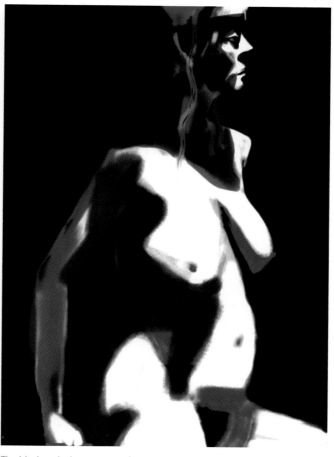

The black and white version of the colour painting illustrates the contrast more clearly. The stark contrasts can provoke rhythm and movement across the composition. Sometimes tonal differences between one colour and the next seem almost indivisible.

Tonal contrast could be the tension supplied by the opposition of warm and cool colours or the rhythm and movement provoked by extreme tonal variation. It may be the juxtaposition of neutral greys with intense flashes of colour. It could be complementary opposites lying next to each other, tonally and intensity matched.

Contrast of hue

Hue is the name given to a specific colour, be it red, orange, blue or green. Contrast of hue is the use of undiluted colours in their most intense luminosity. The most intense expression of contrast of hue would be red, yellow and blue because as primaries they are undiluted. The intensity of a hue diminishes as it moves out from the primary through the secondary towards the tertiary. Contrast of hue is the most basic form of contrast as basic hues can easily be distinguished from one another.

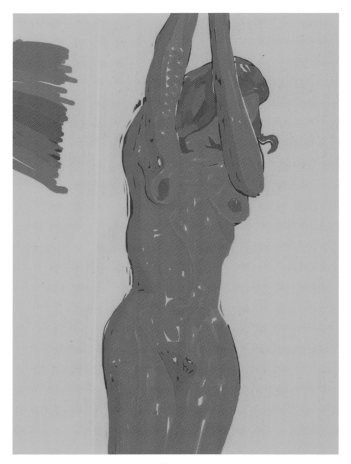

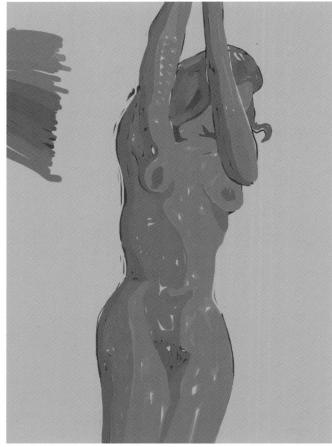

Here we consider value and colour. The aim of this drawing was to try to create an image where all the coloured tones, except for the background, had the same tonal intensity. Imagine the warm light is coming from the right. The warmer colours are on this side and the deeper, cooler colours suggesting shadow and shade are on the left.

When the coloured painting is changed into black and white it becomes clear there are slight variations between the tones. Without greater tonal variations across the colours the drawing looks even and flat, lacking form.

Contrast of extension

Contrast of extension or contrast of proportion is the relationship between two or more colours and their distribution and relative sizes within the composition. It is the contrast of quantity, large and small, much and little. One colour's visual weight in a composition may be intense and significant yet proportionally this colour may only inhabit a small part of the composition. If this colour is allowed to dominate there is a chance it will disrupt the harmony and balance of the whole composition simply because it overpowers it. The balancing act between colours needs to be maintained, whatever the proportion.

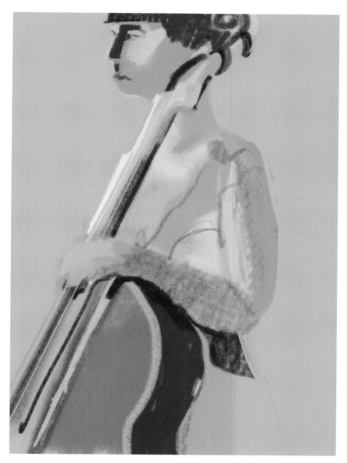

Here we can see contrast of extension. This is also known as the contrast of proportion. The weight or effect of a colour on another or surrounding colours depends on the colours' proportion in relation to each other. A small amount of a given colour might have a giant effect in the composition.

This image shows harmonious colour. Colours that are close to each other on the colour wheel are, by association, said to be harmonious. The colour in this painting is mostly warm with light and dark browns. The introduction of a bright red and blue in the tattoo as a contrast creates an enlivening effect over the composition and a point of focus.

Harmonious colour

Analogous colours are closely related and are found next to each other on the colour wheel. They are harmonious through close association. The further two colours are from each other on the colour wheel the greater the contrast. An analogous combination has little contrast. The combination has a serene, calming or pleasing effect on the eye but at the same time it can be a little bit dull. This can be enlivened by introducing a complementary colour to add some energy, contrast or zing to the painting.

To create dynamic and engaging paintings consider employing some of the contrasting properties as described. The concepts of colour contrast can provide starting points and ideas for the set-up of your figure compositions. This might be regarding lighting, the design of the poses, the use of clothing and materials and the contribution of the surrounding context.

THE COLOUR OF SKIN

What is the colour of skin? Why can you not buy accurate skin or flesh tints in paint even though you may find them in shops proclaiming they are 'skin colour'. That is because there is no such thing as a standard skin colour. A single representative colour cannot be manufactured to be the colour of 'skin'. There are skin types yet the colour and tone of any skin is subject to a number of elements, which change depending on the circumstances. A large factor is light. The light surrounding the skin, the ambient light, will have an impact on the colour. Reflected light from the skin itself, which can act like a mirror, may play its part too. The reflection of colour from clothing or nearby objects can also have an influence as the skin may be picking up some of this. The actual skin itself has its own particularities and these vary from person to person depending on

What is the local colour of the skin you are looking at? Local colour is its unmodified colour not influenced by surrounding colours, light and shadow. Is it pink, red/pink, blue/pink, red/orange, brown, light brown? Identify the local colour and its tonality. The hue may be high, intense or more muted with less colour. Be specific to this person under these particular conditions. Do not generalize. Become aware of any variations of colour across the figure. Value or tone will imply form and depth. What is the light source? Is it warm or cool? Is that making the skin appear warm? A warm light will produce cooler shadows and vice versa. Are the shadows made of a saturated colour? Skin can be reflective. Can you see evidence of reflected light and colour on the skin? If so, what is its origin? Is it from light bouncing from another nearby part of the body or is it a reflection of colour from an outside source?

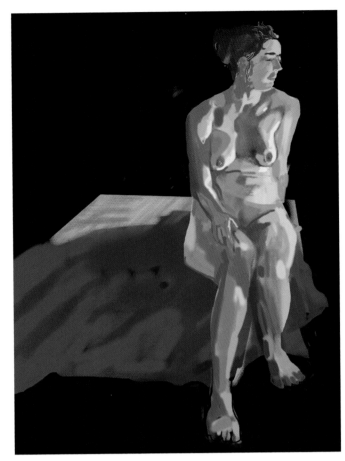

This is an opaque painting. None of the colours in this painting are transparent. All the colour has been applied with a mixture of brush styles, mainly the Hard Brush and the Air Brush set to maximum opacity. The colours are not blended and they have been laid out on top of each other. The focus is on identifying planes of colour, describing the body to give a convincing illusion of three-dimensionality. As the colours are unblended it can make the painting look blocky.

their racial origins. The body generates heat and reacts to external temperature, which, through cool and/or warm colour combinations has its consequences. There may be evidence of tanning with parts of the body being darker in some areas than others. Often there is a difference between the skin of the face and that of the body. Some skins are so light they can appear almost translucent with blue veining visible below the surface. In addition, there may be coloured patches, rashes and other surface conditions. We can generalize a person's skin colour but within it there are other variations.

The best possible way to study accurate skin colour is through direct observation under consistent lighting conditions. Control the lighting and reposition the figure identically for each painting session if working from direct observation.

OPACITY AND TRANSLUCENCY IN PAINTING

Paintings are made with transparent or opaque paint or a combination of the two. Transparent paint works like stained glass. The colour of the ground shines through the transparent layers, giving it a feeling of illumination. The light is refracted from below to produce a rich, glowing effect. It appears more realistic as it mimics the effects of light. The colour range is greater than that of a single colour. It allows you to play with depth and volume.

Opaque paint is non-transparent. It can never emit light itself. Opaque paint is thicker and will not be able to pass light through it from the support surface. In order to suggest light with opaque paint it may be necessary to add white. It is important to know how you will use your paint

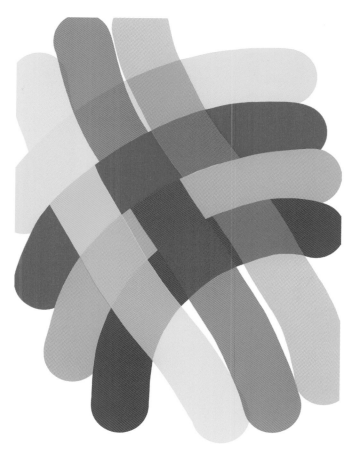

This is a test study using the Adobe Sketch watercolour brush. The similarity to conventional watercolour painting is convincing. The colour is applied wet onto a damp yellow base. As in watercolour itself the edges either blend and merge or dry with a serrated hard edge. The yellow underpainting can clearly be seen shining through in some areas, especially through the green stripe.

This image, made using Procreate, illustrates the idea of transparent layers of colour laid over each other, combining to create another colour. The four strips below are opaque yellow, red, blue and purple. A transparent layer of each has been laid in over the top of the four strips. Yellow over red should produce an orange, yellow over blue a green and the yellow over the yellow, in this case, is indistinguishable, consumed by the opaque layer. Layering and glazing colour will produce an effect not possible with colour that has been mixed. It will add depth and translucency to the painting.

in order to make a successful painting. Different approaches create a different impression of light and dark.

Watercolour approaches

Parallels can be drawn between the convenience of working on an iPad and traditional watercolour painting. They can both be seen as portable and easy-to-manage ways to create images. Their size and convenience facilitates easy access away from the studio space and into the environment or, as in this case, the life-drawing studio in order to work from direct observation.

One of the attractions of watercolour as a technique, but also one of its well-known perceived drawbacks, is its inability to be changed easily, altered or corrected. Some may see this as a limitation. Limitation of choice can be

helpful as it forces you to be inventive rather than picking out solutions in order to try to finish something. Too many choices can lead to indecision and confusion. In watercolour painting going back and attempting to correct an error on paper is a dangerous game. It is not easy to disguise your painting problems in watercolour. If problems do occur it means either abandoning the sheet or adapting the painting in some way. This is possible and can be successful but it is likely to end up as something unforeseen. Once the surface has been spoilt by a mistake you cannot usually 'correct' it seamlessly. The effort to correct will almost always leave evidence of itself and the smooth even surface required would be disturbed; more than likely your surface will blob or patch or buckle or all of these. One of the great qualities of a watercolour painting might be its smoothness and evenness of colour and tone.

The requirement to plan the watercolour, take the risk and push it through in the hope of having control over an unpredictable material gives watercolour its reputation as difficult to handle. It provides the tension in the process

This is an Auryn Ink digital drawing showing how transparent colours laid over each other will 'mix' optically and create new colours. You will notice how the simulated paper texture is visible through the colour. Thick textured paper is traditionally used in watercolour painting to counteract the effects of water and buckling. This study shows what happens when you mix the primary colours. The blue and red, at their intersection, should produce purple. The yellow and blue create a green and the red and yellow create orange. Texture is clearly seen within the marks. As in traditional watercolour painting, sedimentary effects can occur in the textured papers. In this example, subtle pools of pigment have collected within the dips of the paper surface. The granular effect can be exploited as part of the painting. Note how the edges of the colour circles are a combination of broken brush strokes suggesting a dry brush and a clearer, more defined edge. The brush used here is fairly wet. In some areas, it bleeds over into the colour it is interacting with, very similar to the real effect. This is a good example in which to observe transparent layering of one colour over another and to see the difference between the two. Tone is created by the transparency of the colour. The more water, the lighter it is. When layers are overlapped, the colour is darker. Too many layers and it would get too dark.

This image shows the same effect of colour layering with actual watercolour paint on paper.

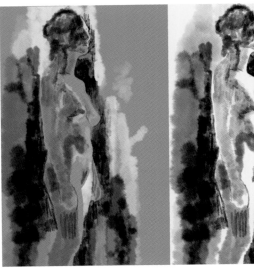

This painting was made using the Water Brush from the painting options in Procreate. The identical study has been placed onto two different coloured background layers to demonstrate the transparency of the colour. The background colour has a substantial effect on how we see the same colours in the painting. The darker blue background creates contrast with the lighter colours intensifying their effect. The reds and browns also respond vividly to the blue. The lighter, less colourful background illuminates the colour and allows it to glow.

towards success or failure, which can provoke interesting results and also demonstrates skill in planning and execution.

Using the iPad to work in a watercolour technique is possible. Layering, opacity and the ability to undo makes painting transparently easier on the iPad than on paper. If working layer on layer you could delete the troublesome layer and try again without disturbing anything previously done. All apps have an opacity slider so any brush choice can be layered over another to explore transparent glazing. You will not need to wait for anything to dry and your paper will not buckle from the effects of water.

Auryn Ink is a watercolour app. Adobe Sketch has a watercolour brush option. Both of these apps are capable of achieving incredible results by emulating the qualities of watercolour on the paper surface.

Think a little about how light and colour works. We have an object and that object is yellow. Yellow is its local colour. This yellow object, like any object, is subject to the influences of the light around it and falling on it. If I shine blue light the yellow object might look a little green but whatever happens it will change colour. If the light creates shadows on its surface those shadows will be a combination of dark yellow, a green and possibly a hint of orange. Coloured light creates complementary shadows. So blue

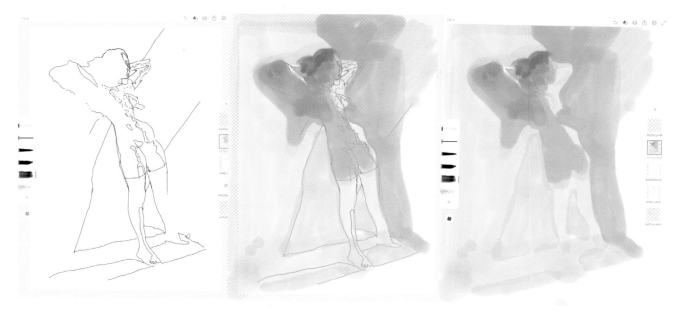

A reference layer will provide guidelines for the painting. It can be hidden or deleted once it has provided enough information.

light casts an orange shadow, red light a green shadow and yellow a purple shadow. Well, that's the theory in perfect conditions. We are not working under perfect conditions but we can still use the theory to help us interpret what we see.

The idea behind this is that building up a watercolour painting is similar to how we experience light and reality. We can say that when we look at an object it is subject to all the different layers of light acting upon it.

In a palette of traditional watercolour paints there should be no white. A distinct quality of watercolour is the ability to overlap transparent layers with flat washes of colour. This will add depth to the painting whilst allowing the light in the paper to shine through, giving a translucent effect. The tonality of the colour is determined by the quantity of the light shining through the layer. The addition of white paint would turn transparent colours into opaque colours and so would destroy the effect.

Colour combinations can be arrived at through visual mixing. One layer of colour over another will combine to produce another colour. This is not a mixing of paint pigments but of layers of colour. For instance, a thin layer of a blue over a yellow can appear to produce a green.

Underdrawing – transparent washes over the top

When preparing a traditional watercolour painting, you have a choice of two approaches from the outset. The first approach is to draw out and plan the composition first in pencil as a guide for the painting. This would need to be fairly faint or else the pencil marks might show through any delicate areas of watercolour. The other approach is to begin painting without any underdrawing. One method is not any better than the other. On the iPad, it is possible to use a reference layer for the drawing, which can be erased or left in place as desired.

Overlapping transparent layers in order to build colour and depth as in the traditional watercolour painting approach is easier on the iPad. There is no danger of disturbing the layer below. This is the hazard of working with real paint. The wet over dry layer with paint needs to be the correct consistency and to be applied without agitating or diluting the lower layer. On the iPad this can be attempted as many times as needed by either using the undo button or, if the glaze is on a separate layer, deleting the layer.

Bleeding

Watercolour has a wonderful way of bleeding unpredictably from one colour to another when applied wet into wet or variations of wet on damp paper. This will often bring about seductive combinations of colour in unpredictable configurations. With practice using Auryn Ink and Adobe Sketch, you will get a sense of what running colour can and might do and with experience you can manipulate the effect to your advantage.

Stopping out

The bleeding effect of watercolour is one of its well-known features. Another is stopping out. With some careful planning you could work out where the highlights would be on your sheet of paper. A highlight will be the lightest, most intense light in the composition. Rather than flood paint all over the surface and in the process risk losing your chances of saving your highlights you could might use stop-out fluid. This liquid is painted onto the intended areas of highlight, where it dries and reserves for use later the areas you need to paint on. It protects whatever is underneath, leaving you free to paint over the surface. Once dry, the fluid is peeled off to reveal the stop-out areas and those can then be painted in the right colour. The equivalent to stop-out fluid in both Auryn Ink and Adobe Sketch is the simple eraser option. As with any other tool, use the eraser on a lower strength in order to simulate the action of sponging or dabbing out. If a strong sharp area of light needs to be erased in order to include a highlight, the erase option can be set on maximum.

Drying control

With traditional watercolour you need to let adjacent areas dry before working on a new area, or else you will get bleeding where you might not want it. This is not necessary with Auryn Ink and Adobe Sketch. You can control the colour drying to stop the colour from bleeding and reacting with other colours by utilizing the hairdryer or fan.

Colour mix and saving to the palette

With watercolour you are punished for dithering or not mixing enough colour. If this happens, continuity and momentum are broken and you will probably end up with a blotchy mess. This will not happen digitally. Your colour is in infinite supply, enabling you to colour pick the identical mix every time, especially if you have previously saved the mix to the colour palette.

Seamless blending and gradation are difficult to achieve with the apps. This image shows a fairly smooth transition in places across the colours. It was made in Adobe Sketch using a watercolour brush. The flow option was reduced after the initial stroke of colour was laid in and whilst the paint was still active it was brushed in again in the hope the edges would disappear and create a seamless transition. It is not as smooth as paint on paper can be.

Blending and gradation

When painting, you may need to blend a seamless gradation of one colour. This is difficult enough with paint and paper and difficult on the iPad. On paper, the surface would be prepared by wetting, and the paint would be applied wet into wet or damp. Too wet and your paints will go everywhere; too dry and you will end up with streaky brushwork rather than a seamless mesmerizing transition. With the watercolour brushes it proved difficult to get a seamless blend. Smooth transition is vital in some instances. A combination of colour intensity and flow seems to be the most effective approach.

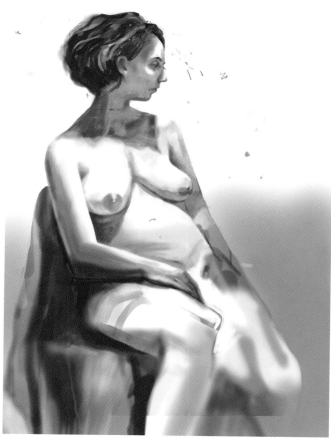

The blending for this transparent painting was made in Procreate. Some of the watercolour qualities, such as the bleeding of one colour into another, that make Adobe Sketch and Auryn Ink distinctive are missing in Procreate. However, subtle blending in this case was made easier with the use of the eraser tool on a low setting to smudge out any garish transitions. Blending on separate layers over each other is possible in order to have control of the painting should something go badly wrong. Choose a brush that creates non-solid edges such as an airbrush or spray paint and adjust the size and opacity to gain control. Approach with caution, build transitions slowly. Once the layers are working well together, merge them as one layer. To do this you will need to reveal all the layers of the painting by tapping on the two overlapping square symbols on the right at the top of the screen. Tap on the chosen layer to reveal a list of options that appear to the left. 'Merge down' will amalgamate the chosen layer with the layer below it. Alternatively, it is possible to pinch layers together using your fingers. You can pinch together every layer if required to leave just one single image.

This image demonstrates a number of approaches to blending. The iPencil will create very subtle shading, allowing transitions in a similar way to using charcoal, pencil and pastel. Some brush styles may not be quite as easily manipulated. Transitions between colours and tones can still be achieved by using the eraser and/or the smudge tool on an appropriate brush setting and adjusting the opacity level to help maintain control over the subtlety of the gradation. The eraser can be used to erode a hard edge of two overlapping colours or tones to give the impression of a smooth blend. The smudge tool in Procreate is particularly effective.

GROUNDS

Cennini recommended the use of green underpainting for flesh tones. He ensured that the 'terre-verte may not fail to tell', creating a cool-warm contrast. Rembrandt would use a dark brown ground so his images emerged from the dark into the light. This is similar to the charcoal tonal drawing approach where the surface is covered with a preliminary mid-range tone. The Pre-Raphaelites favoured a white ground in order to inject brilliant luminosity into their paintings. Some opt for grisaille, a method of painting in grey monochrome, initially intended to imitate the dimensionality of sculpture but also used as a tonal underpainting for the building-up of coloured washes. Others go for a *verdaccio*, or an *imprimatura*, a lightly applied, transparent stained ground. Artists have used a number of different approaches to underpainting throughout the history of painting. You might have a preference once you explore a few approaches.

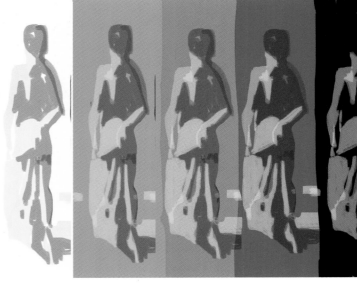

The figure has been drawn in transparent shapes reflecting the basic distribution of light between light and dark. The left-hand panel is the original drawing on a white ground. The following four versions have taken exactly the same drawing at the same level of transparency and changed the background colour. This illustrates the effect of the background colour shining through the drawing and altering the relationships in each case. On the black background the lighter side is almost the only element visible as the contrast is stronger. In this drawing, the darker side of the figure disappears as it is overpowered and consumed by the darkness of the background.

Transparent painting and the figure

One method would be to work wet on dry. The first layer would establish an overall colour. This would be a light version of the local colour of the figure, the lightest skin tone. You would have to plan for and reserve any highlights at this stage as each layer goes in. Each layer would be wet on dry, fading out if a gradation was needed. The colour would build up in intensity and tonality over the layers.

COLOURED GROUNDS

Artists use a coloured layer as a ground for the painting for a number of reasons. One good reason is to eliminate the intimidating stark whiteness of the painting surface. Working on a white surface can have an overbearing impact. Colour on a white ground can look darker. This makes judging value relationships more difficult. Seeing highlights against a mid-toned ground is easier. In addition, if areas of the background colour are left white, this can give the painting an unfinished look.

The ground will have a different effect if you are working over it with transparent colour as you would in watercolour painting. White is a good base for the overlaying of transparent colour as it will shine light through the paint from the surface, altering its colour and tone, giving it a sense of illumination. A light-coloured ground for a transparent painting will have an influence too. Any transparent colour laid over it will be tainted by the base colour.

The ground will have a dramatic effect on the painting and will influence its mood and feeling. Any colour can be used but it is worth thinking about the purpose and the consequence your choice might have. If traces of the ground are visible between the brushstrokes, they will react with the colour scheme, either in opposition to or in harmony with it. If you use a colour that prevails in the painting as your ground colour, it will have a unifying effect on the composition. Different-coloured grounds will alter the perception of the same painting. A neutral colour will help you judge the value and intensity of the colours applied, making it easier to lay in the relative light and darks. If a complementary or contrasting colour is used, this will create a strong reaction in the image.

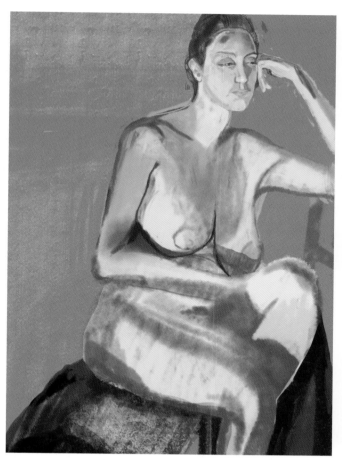

A neutral ground will provide you with a tone to work against, as opposed to white, and a colour that will enhance and not compete with your palette.

Having an almost muted, complementary green/red figure and ground relationship will make the colours react to each other, giving them life, brightness and energy. The painting intentionally allows parts of the background layer to show through in between brush strokes in order to provoke the colour contrasts.

If the toned ground itself is transparent, a further dimension will be added into the composition. The parts that show will have added luminosity. The colour will be responding to the painting layers above it and if they are predominantly opaque then the suggestion of depth will be emphasized.

As already mentioned, contrast in colour plays a significant role in the effect the painting will have. Prepare to use contrast in your colour schemes to help bring the painting to life. The Procreate background layer colour can easily be inserted by scrolling through the palette to establish something appropriate to your intentions. Try out several options. Think in terms of opposites such as a warm ground for a painting dominated by cool colours and a cool ground for warm colours. Allow parts of the ground to show in places and react with the painting layers.

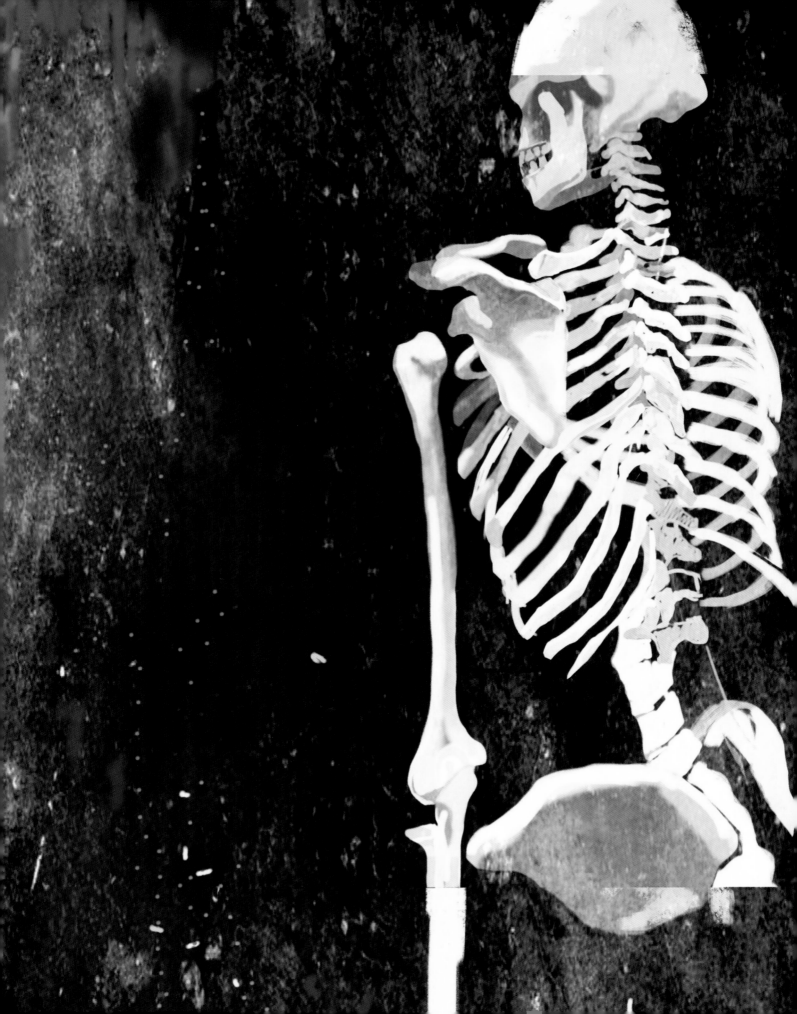

Being Inspired

The styles of the past were developed by copying. Paintings come from paintings...
Giorgione knew Mantegna and Giovanni Bellini, and employed Titian, who knew
Tintoretto, who was followed by El Greco, who was copied by Picasso.[25]

JEFFREY CAMP

Tintoretto obsessively drew small-scale plaster models of sculptures by Michelangelo, lit by an oil lamp to provoke dramatic deep-cast shadows. The soft tonal progressions of Leonardo da Vinci's *sfumato* were learnt from his teacher Andrea del Verrocchio. The bold gestural marks of Rubens are displays of human action full of energy and movement. Egon Schiele's believable yet tense linear distortions and elongations charging through the figure demonstrate his understanding of anatomy and allow the figures to be convincing. Caravaggio's cinematic lights and darks fill the negative spaces with mystery and suggestion. His unidealized streetwise characters step out of the shadows, half-caught in revelatory intense illumination. Degas copied as much as he could. In Rome, Naples and Florence between 1856 and 1859 he copied the work of, amongst others, Titian, Mantegna, Donatello, Raphael, Michelangelo, Fra Angelico, Uccello, Filippino Lippi, Carpaccio, Botticelli, Signorelli, da Vinci, Bellini, Perugino and Giorgione. Degas had his own vast collection of paintings to work from that included Ingres, Delacroix, Daumier, Manet, Cézanne, Van Gogh, Gauguin, Pissarro, Cassatt and Morisot. 'It was through imitation that he discovered and trained himself, instinctively drawn to the greatest: he was of their breed, following in their footsteps.'[26]

Expose yourself to art and learn from it. Look for work you admire. It is fairly easy to find great examples of drawing and painting of the figure on the internet. It is possible to work directly from the screen but there are much better ways than this. The screen has its limitations, scale being one. Do not work from tiny images. Your experience will be limited as you will not be able to see enough. The details themselves may not even be visible. It is better to go to a library and find books on artists. Try to work from large, good quality reproductions so you can see the image clearly. If you need the reproductions of the images, copy them and print them big.

Artists reveal unperceived beauties to us in art, just as they do in nature.[27]

NEIL MACGREGOR

The best method by far would be to see the actual artworks at the museum or gallery for maximum visual stimulation. You will see so much more and it will make a difference. A reproduction has no tactile qualities or realistic scale and might even have some distortion in colour, tone or composition. Nothing beats the experience of a confrontation with a real artwork, seeing it as it was intended, in a real space. The elements that make up the work and how it was made may reveal new and meaningful insights into your perception of what a painting or drawing can be and how that in turn has its effect. Keep going back and looking at the same things as well as the new. The work will reveal itself on each subsequent visit.

The portability and immediacy of the iPad makes it ideal for visiting museums, working there discreetly, quietly, efficiently, mess-free. A mobile studio with all the materials you might need is in your hands. The National Gallery, the Victoria and Albert Museum and the British Museum, in

CONTRAPPOSTO

Contrapposto, meaning counterpoise, is a naturalistic, relaxed standing pose with the body weight on one leg, creating a natural twist. The other leg is non-weight bearing. The weight-bearing leg is pushing the hip up, compressing that side of the body. The angles across the figure oppose and complement each other, making the pose asymmetrical. Observe the axis lines running through the ankles, knees, hips and shoulders. They give the whole torso an s-curve. This creates the impression of past and future movement.

Contrapposto was a revolutionary development as it made the sculpted figure seem natural, convincing, alive and capable of movement. It was developed by the Ancient Greeks in the early fifth century BC in reaction to the prevalent stiffer static poses of earlier Greek sculpture. The Greeks believed the human body was an object of great beauty and strived for new ways to express that. Their expanding knowledge was based on the observation of the natural world and the human body responding to the specific information encountered rather than to general ideas. The *contrapposto* pose was revived during the Italian Renaissance and used to great effect by Raphael, Leonardo da Vinci, Donatello and Michelangelo.

David by Michelangelo demonstrating the pose.

London, are just three places where you will be inspired by other artists' depictions of the figure in painting, drawing, printmaking and sculpture. The effect of walking through the Cast Courts at the Victoria and Albert Museum, which date from 1873, is spectacular. There you will find an incredible collection of casts of post-classical European sculpture. Scale, monumentality, drama and skill are all displayed in excellent copies, amongst others, of a number of Michelangelo sculptures such as *David* and *The Dying Slave*. Here you can sit in awe and draw from any angle from these great examples. Easels and seats are generally available at museums and art galleries for people who want to sketch.

I think one's only hope of doing things that have a new presence, or at least a new accent, is to know what exists, and to work one's way through it, and to know that it is necessary to do that thing…go and draw from pictures to remind myself of what quality is, and what is actually demanded of paintings.[28]

FRANK AUERBACH

What are you looking for when copying? You are looking for ways other artists have seen the figure in their world. What are the qualities we can learn from great art? Drawings, paintings and sculptures will provide you with tremendous examples of the foundations of painting and drawing. You will gain an insight into the artists' thinking process, how they have solved visual problems and share a sense of how artists have used their chosen material to do this. A drawing might inform you about choice. A good drawing is the result of a series of decisions. There might be an emphasis on something in particular that has been enhanced and exaggerated. This will help you to learn about specific ideas and developing them.

The rules of the game are determined when the artist decides what kind of faithful record of which aspect of the experience shall be made. For, regrettably, the artist cannot transmit the total experience.[29]

PHILIP PEARLSTEIN

You will be able to take from this what you might need to progress your work. Reacting to something you have chosen and studying it will enable you to learn more about style and technique than simply looking at it.

There is an immense difference between seeing a thing without a pencil in the hand and seeing it while drawing it. Even the object most familiar to our eyes becomes totally different if one applies oneself to drawing it: one perceives that one didn't really know it, one had never really seen it.[30]
PAUL VALÉRY

Artists see and react in their own way. Their response is particular. They have a style and that may be what attracts you to the artwork. What are they showing you and how have they made this image? What do they need to show to communicate this? You may respond to one or a few elements in particular: the light, structure and form, the anatomy, colour, the suggestion of a narrative, the rhythm and movement of the composition and how the lines, colours and shapes convey something intentional. It may be the space and the figures' position within it, patterns, shapes and textures.

Through practice and repetition comes knowledge. With the knowledge there is confidence. Michelangelo, when painting the Sistine ceiling and *The Last Judgement* probably did not have unlimited models at his disposal. How did he paint all the figures in such a vast array of poses? He did it because he could visualize and he could do that because he had seen and understood how to draw from and redraw the human figure from his imagination in any way required. This is the work of a man with an intimate knowledge of the human form.

The sculptural qualities and monumentality of Michelangelo's figure drawings are palpable as is the obvious delight he took in rendering the vast anatomical landscape rippling over and across the bodies of his figures. The musculature is energy charged with a potentiality, tense and dynamic. In *The Last Judgement* he depicts figures from as many angles as he can. How do they react, and relate to each other? How does the light describe them and what space do they each occupy in relation to one another? These are some of the qualities we can see and study in Michelangelo's work. In particular, we can study anatomy.

The knowledge gained by copying the work of an old master or an artist you admire is invaluable. You will be forced to see the figure like you have never seen it before. Find out what appeals to you by looking through another artist's eye.

COMPOSITION AND NEGATIVE SHAPES

Composition is the art of arranging in a decorative manner the various elements which the painter uses to express his sentiments. In a picture every separate part will be visible and...everything which has no utility in the picture is for that reason harmful.[31]
HENRI MATISSE

One of the essential elements of a visual image is its composition. A unified symmetrical whole or a deliberate asymmetrical un-balance can create tension and so affect our reaction. Power lies in a well-constructed composition as it guides our eye around the painting with maximum impact. Finding the key shapes through simplification will reveal the geometry of the painting, helping you to understand how the elements are working together. The negative shapes are the places where, seemingly, there is nothing going on, an area easily neglected and unconsidered. They are often seen as the redundant spaces the subject does not occupy. However, negative space surrounds the object in an image and contributes as equally to the balance of the drawing or painting as the subject itself. As Debussy said about music, the silences are as important as the notes; and so it is in painting and drawing.

Expression, for me, does not reside in passions glowing in a face or manifested by violent movement. The entire arrangement of my picture is expressive; the place occupied by the figures, the empty spaces around them, the relationships, everything has its share.[32]
HENRI MATISSE

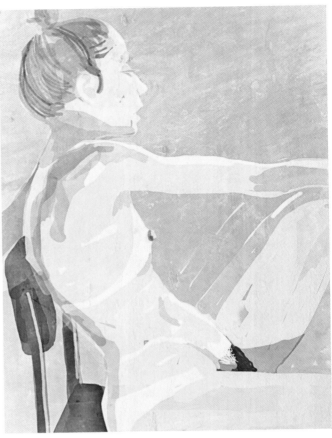

This is a copy of a Richard Diebenkorn painting, from 1967, which illustrates the arrangement of the positive and negative shapes. The figure is seen side on and simplified into flat shapes. A large proportion of the negative space is background. Equal emphasis has been placed on the negative shape. It is not a flat consistent colour but the paint has been scumbled and layered onto it, suggesting a level of depth. All the shapes work together like a jigsaw puzzle to balance the complete composition.

This image illustrates the negative spaces without the background layer.

This iPad painting of Ariane works in a similar way to the Diebenkorn example. Depth of tone has been deliberately restricted to make her appear flatter against the strong negative shapes within and around her. Similarly, the background colour is layered in order to reflect the way the figure has been painted, avoiding excessive contrast of flat even colour against the painterly figure.

When you look through a camera your image is bound by the frame. A painting and a drawing have to adhere to the same rules. If you are making a drawing of the figure in a setting you need to consider the context and how that is represented in the composition. What will be included? The edges contain the action between them. The negative shapes and the positive shapes and how they interact within those four edges are crucial. Do not focus all your attention on the positive shapes and have the rest as incidental filler. Think of liquid in a cup. What is there is also a result of what is not there. They are combined and co-dependent.

By focusing on one figure we can consider how that figure relates to the surrounding space and any objects within that space. There is an opportunity to design the composition in a way that determines its focal point. Edward Hopper's compositions used positive and negative

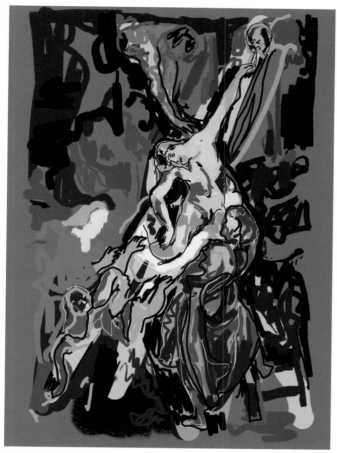

Rubens uses rhythmical linking in his painting *The Descent from the Cross*, 1612–1614, to lead the eye through it, connecting one part to another, supporting the drama by involving all the participants. This quick study illustrates the two links from the top to the bottom, creating a basic x-shaped composition within the frame. Heads, hands, and drapery connect and overlap with each other in order to allow the eye to run through rhythmically down and reinforce the action of Christ being gently lowered to the ground.

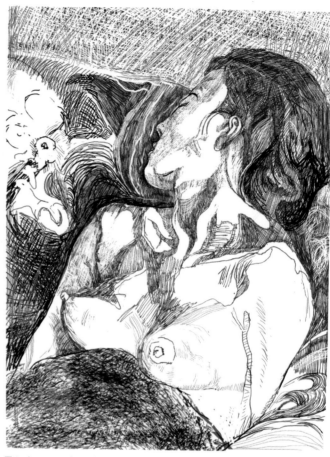

This drawing is based on an oil painting by Lucian Freud called *Pregnant Girl*, from 1961. The original intention for this copy was to study the dynamic compositional arrangement of the figure within the rectangle. The girl is beautifully contained and framed by the cover over her lower body and the couch she sleeps against. This arrangement is closely framed by the edges of the composition. Once the basic shapes had been established, the drawing became an exploration of the contrasts of light and dark and the shapes, rhythms and textures existing within them. Hatching and cross-hatching are created using a selection of brushes from the inking option in Procreate.

space extremely effectively to provoke the sense of isolation and insignificance an individual may feel in the city. Richard Diebenkorn used negative space as a powerful element in his figure drawings and paintings to emphasize shape, pattern and rhythm. Degas was influenced by photography and the cropping of the figure by the edges of the frame.

Use the layer options to crop your image in a number of different ways. Zoom in and out and explore the framing, altering the relationship between the figure and how it occupies the space around it. Record the images as reference using screenshots as an equivalent to thumbnails sketches. For further notes refer to 'Finding a composition' in Chapter 1.

RHYTHM AND MOVEMENT IN THE COMPOSITION

The implied line running through the figure will be dynamic or static. The *contrapposto* pose, for example, is dynamic. The s-shaped line running through the figure implies movement and energy. If there is more than a single figure in a composition, relationships run between them through their placement and proximity. The great figure compositions of Poussin and Raphael are extremely carefully worked out. They are designed to lead and guide your eye through the composition to focus on something in particular. Figures overlap and connect building patterns into the arrangement in order to build tempo and rhythm.

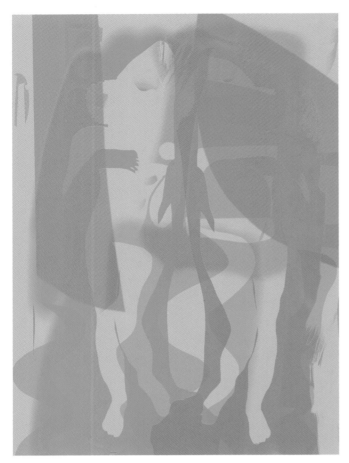

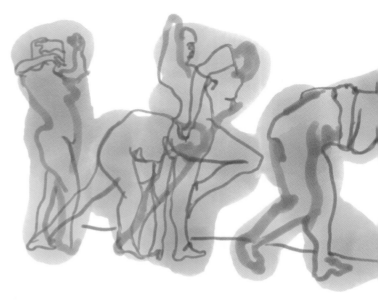

Many of Rodin's figure drawings are very fluid, made up in a combination of puddles of watercolour and line. The model suggests movement through this drawing as she moves from one pose to another. The drawing, made in Adobe Sketch, begins with a watercolour base establishing the general shape and dynamism of the pose with a linear layer describing the pose in more detail. Each pose was approximately one minute.

Using a combination of the eraser and the select and transform tool, you can work with bold flat shapes to create a composition over a number of interchangeable layers.

SHAPE

Matisse, in his *Blue Nude* cut-out series from 1952 abstracted and simplified the figure into a series of silhouetted shapes, which collectively make up the whole figure. Using only blue-painted paper he cut out the flat shapes, assembling them together to get to the essence of the gesture. The American artist Tom Wesselmann, himself influenced by Matisse, used flat forms in a number of his paintings, collages and sculptures. The nude figure, or a detail of it, was often one flat colour with selected elements within it in further detail.

Focus on shape using a combination of the eraser tool and the select and transform tool in Procreate. Once a shape has been selected it can be duplicated, resized, flipped and reversed. Duplicating the shape is easy and the layer tools will enable you to manipulate the selection and explore scale, patterns, rhythm and composition.

LINE

As we have seen in Chapter 5, a line can be drawn in so many different ways. Its quality depends on the material, the surface and how it is applied. David Hockney's taut, brittle, decisive line drawings of his friends and family from the late 1960s demonstrate his skill and patience. Using a pen, the opportunity to rework the drawing is denied, so the tension of approach is imbued within it.

Line can also be made rapidly in response to a moment seen. Rodin worked directly from the model. His pen and watercolour wash drawings of the figure are fluid, free and expressive. Detail and proportion can be compromised to an extent under such conditions, as capturing the energy, movement and vitality of life are what these drawings are about. Rodin disliked the academic approach to drawing the figure. He preferred to have his models moving around his studio. He had men, women and children posing in his studio at random, almost like an indoor nudist colony.

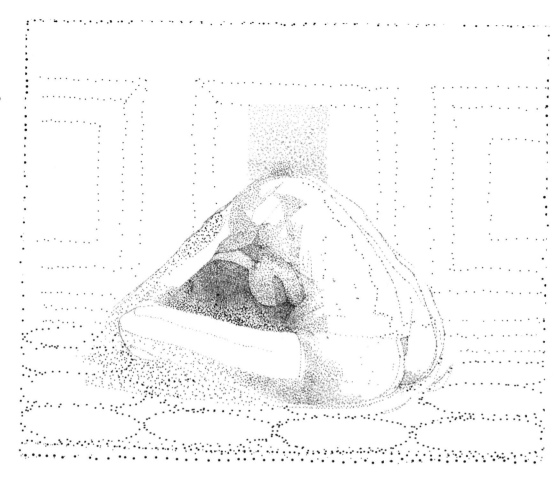

This stippled drawing is a partial copy of Euan Uglow's *Pyramid*, 1994–96. The intention behind the drawing was to record and understand how the figure has been divided into planes and how the space is described and occupied by the form.

He would walk and draw amongst them, responding with rapid sketches. He disliked static poses and encouraged the models to move freely. His spontaneous drawings are predominantly toneless expressive linear renderings.

LIGHT, STRUCTURE, FORM AND THE BODY IN SPACE

Euan Uglow's paintings and drawings of the nude are characterized by meticulous measuring, their sculptural qualities, compositional exactitude and sensitivity to tone and colour. His figures are posed in such a way as to emphasize geometric shapes and articulate the form through clearly defined planes. More dramatic contrasts of light and dark can be seen in Caravaggio or Kathe Kollwitz. Uglow's work is useful to study as it clearly demonstrates his preoccupation with describing a convincing three-dimensional form within a highly controlled setting.

MARK-MAKING

Van Gogh in his later drawings of the late 1880s was able to powerfully combine expressive and descriptive mark-making. The dots, the dashes, the curves, the variations of scale and value, the intense areas offset against sparser sections create a vibrancy and energy, providing the eye with spatially and texturally compelling illusionistic depictions. Van Gogh teaches us that a drawn line is not just a drawn line. He instilled his line with veracity and an energy that continues to elude classification. His graphic resources, stippling, cross hatching, a barrage of multi-directional slashes and whorls, were always contained in smartly delineated compositions.[33]

ERIC GELBER

The way a painting or a drawing is made will have a bearing on how it is seen. How does that affect your experience of the work when viewed in reality as opposed to in

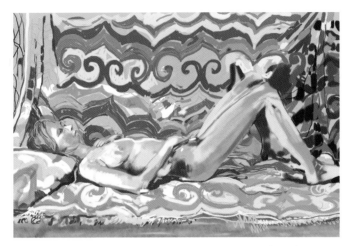

Attract interest to some areas of the composition as opposed to others. In this image, the figure as the positive shape is almost consumed by the power and intensity of the surrounding pattern used as a backdrop. This is reminiscent of Matisse's *Figure and Ornamental Background*, 1925, wherein the decorative background space threatens to impose itself onto the foreground space and create spatial ambiguity in the composition.

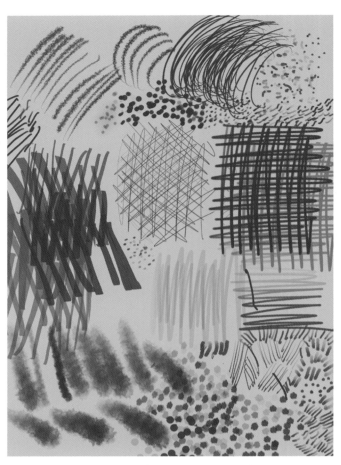

This page emulates the variety of marks used by Van Gogh in two portraits dating from 1888.

reproduction? Was the work made quickly or slowly? What is its scale? Does that tell us anything about how the marks are made and what the artist did or had to do in order to make them? Does this add something to the sense of presence? Ask yourself and answer these questions when you are in front of the work.

ANATOMY

You need a feeling for it (anatomy) – which doesn't necessarily mean medically, but to do with movement and how the limbs relate to each other and the body. I've seen some marvellous Renoir drawings, for example. But there is a question about them that is not an aesthetic one. His figures' bones aren't quite right, are they, on the whole? Or you wonder if they've got any. Even when they work, they can make you wonder about anatomy rather than art. With a good drawing you can see the bones.[34]

LUCIAN FREUD

What is the importance of knowing about anatomy? To make convincing drawings of the figure and to build drawing confidence it is useful to have at least a working knowledge of anatomy. Studying the structure of the body and having a sense of the skeleton, muscles and tendons and how they work together will be extremely helpful. You do not need to know all the names of the muscles

and bones in order to understand anatomy. Any pose and movement of the body is dependent on the machinery beneath the surface of the skin. The more we understand the internal architecture and how it works, the easier it will become to render the form and structure we see on the surface. With this knowledge you can also visualize more effectively, and make informed, dynamic and imaginative drawings of figures based on know-how rather than vague guesswork. You will know what to expect and what to look for. It will fuel your confidence to create believable figures in any pose whether working from observation or imagination.

Differences between men and women

We already know that male and female anatomy has its differences. These are some general guidelines to be aware of. Women tend to be curvier than men. They carry more fat so they are rounder. As a result, women have a less defined musculature. Fat can gather on their bottom and thighs. They have wider hips. The female pelvis is lower

Most art schools and life-drawing rooms have a skeleton. It is likely you will come across one. The adult human skeleton has 206 bones. Draw the skeleton whenever you can. Even if you only draw sections of the whole, get to know its structure and become conscious of how we can see and feel it under the skin's surface.

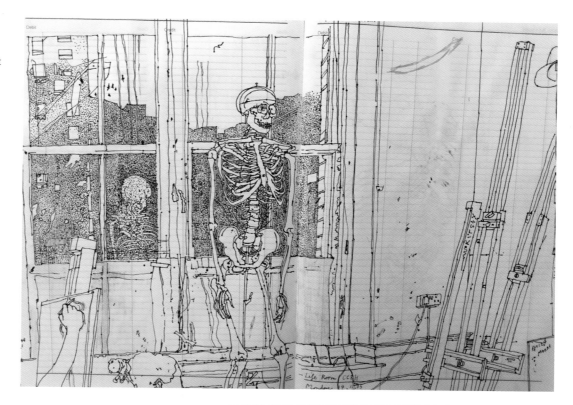

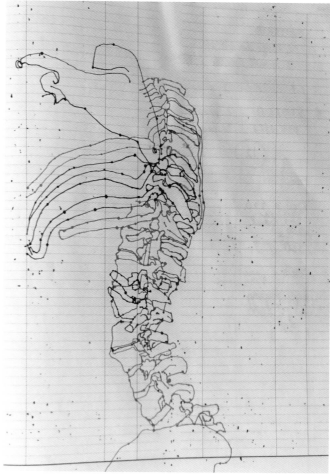

By drawing the skeleton we will get an understanding of bone shape, proportions and their configurations. The backbone or spine is a major support running along the axis of the body. It enters into the back of the head at an angle. It consists of thirty-three interlocking bones called vertebrae. From the front and back it appears straight. A lateral view reveals its curvature, which makes it stronger and shock-absorbent.

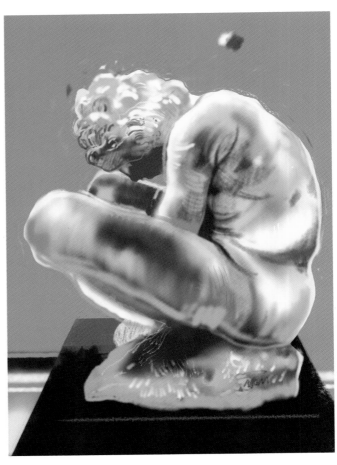

These three drawings were made using Procreate in the Cast Courts at the Victoria and Albert Museum in London. They show a late-nineteenth-century cast of Michelangelo's *Crouching Boy* of 1524 seen from three different angles. When drawing sculpture, consider it as a three-dimensional artwork that needs to be observed from a number of viewpoints, not just the front. Michelangelo's work was considered to be the height of Renaissance sculpture and was often reproduced in the nineteenth century in order to be studied by students.

and proportionally smaller than the male's. It is adapted for gestation. Their shoulders tend to drop a little. Their feet are proportionally smaller.

Men have greater muscle development and definition. Built for hunting and fighting, they are bigger and stronger physically. They have squarer shoulders that are wider than the hips. Fat will concentrate on their belly. They also have an Adam's apple, made of cartilage, sometimes seen as a protrusion in the neck.

The skeleton

If we were to drape a sheet over a chair we would see in various places the basic structure determined by the shape the sheet took. We can imagine the material of the sheet is the skin and the chair is the structure below guiding the shape. Even though the chair is covered, there may be enough evidence visible to suggest what the shape actually is below the sheet. The skeleton acts in a similar way, occasionally making itself visible on the surface of the skin at various parts of the body. The surface evidence would usually be the collar bone, the hip bone, parts of the rib cage, some of the vertebrae, the ankle, the wrist, the elbows, much of the skull, the base of the neck, the hands, feet, knees and shins.

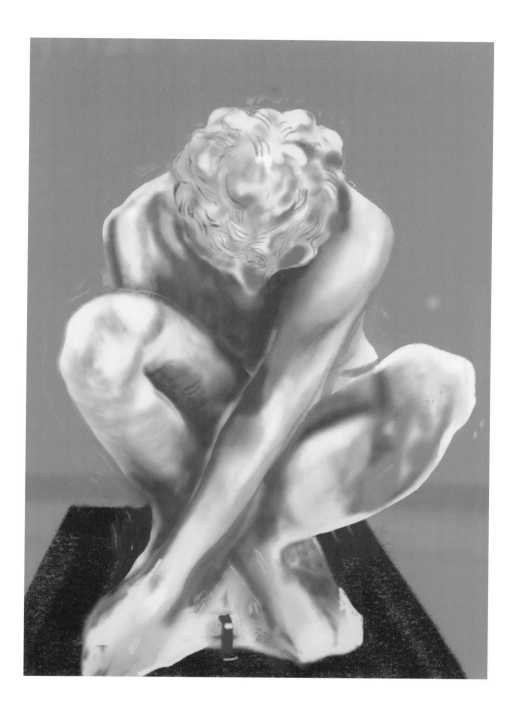

Muscles

Muscles I know; they are my friends. But I have forgotten their names.[35]

JEAN-AUGUSTE-DOMINIQUE INGRES

Muscles are visible all over the body. Some muscles are used for movement and others are essential for keeping the body in position. When drawing the figure, look out for tensed muscles and relaxed muscles. Muscles can be grouped into categories and a study of these would be instructive in order to understand their distribution and significance. Tendons are also visible on the surface under the skin at the wrists, the back of the hand, the back of the knee, on the top of the foot, the Achilles heel, the front of the ankle and the front of the neck.

As a teenager Michelangelo was already attending and performing his own dissections. He developed a vast knowledge of human anatomy and his drawings, frescoes and sculptures are excellent examples to learn from.

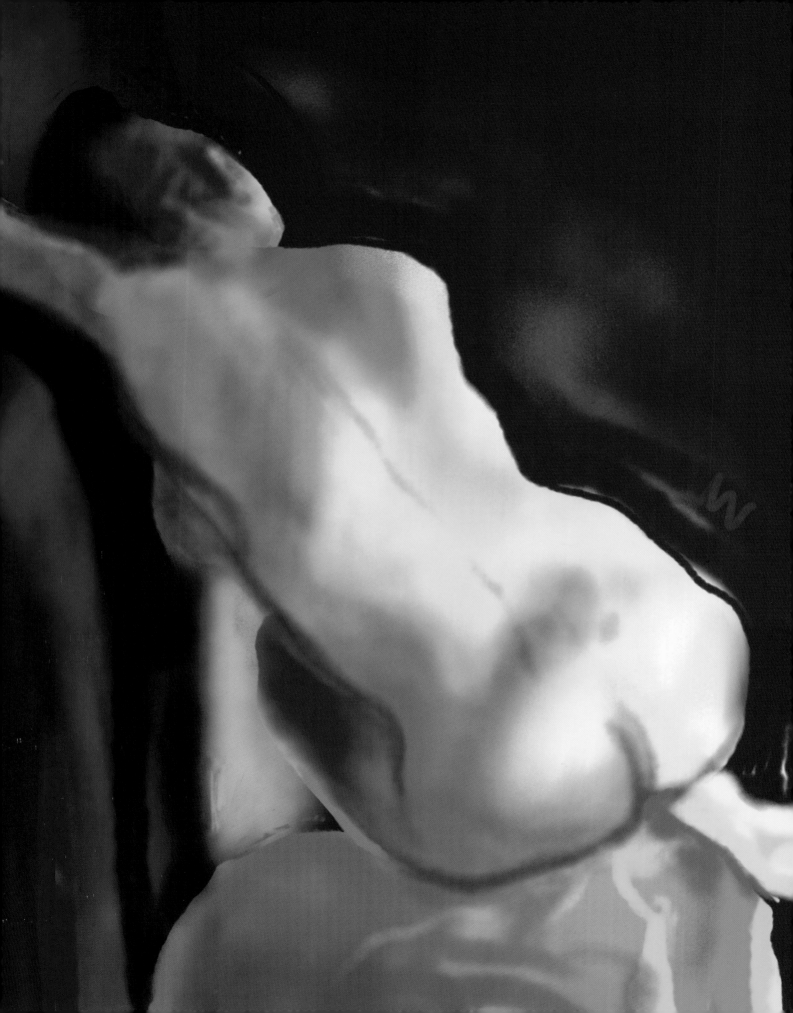

What to Do Now?

ART IN A VIRTUAL WORLD

Viewing habits for art have been changing. In 2016 visitor figures to art galleries in the UK declined by 1.4 million. This was the first drop in almost ten years. Why? Can this be attributed to the power of social media? Who knows where visual technology will lead us in the future? Invaluable is the world's leading online marketplace for fine art, antiques and collectibles. Their data from a US survey in 2016 demonstrates how consumer attitudes and preferences are changing. More people discover art through social media than they do from visiting museums and art galleries. Predictably it is the younger generation, aged eighteen to twenty-four, who are more likely to discover and purchase art online. That is how they connect and engage with the world in so many ways.

As technology develops and our exposure to it becomes even more habitual, seductive and necessary artists and designers will continue to find new ways to utilize these new incredible tools to share and communicate their ideas effectively. Working digitally has its advantages. Some of these have been explained in the chapters of this book. Technology now enables creative people to share their work in exciting new ways. What further impact might this have in the future on displaying, viewing and selling art?

What next?

Once you have created your art, there are a number of things you can do with it. It all depends on what your work is for and who you want to see it. Perhaps the work is for your own website or social media account. You may be trying to sell prints, sell yourself to a gallery or apply for a residency. You may be sending work to a collaborator or having it published in a magazine. Apart from using the apps to discover new responses to visual ideas and expand your potential creatively, it is useful to think about the next stage.

Sharing and feedback

You can easily send your work online to the global community, amongst friends and other artists. Most artists want to share their work and develop creatively. Feedback is essential for a visual artist. Showing your work online will open you up to comments and responses. It can sometimes be difficult to be objective about your own work. You may be too close to it, unable to see its strengths and weaknesses. How it is perceived by others, both positively and negatively, is going to be useful. Most people who attend life-drawing sessions are eager to share. It is fascinating to see how others are responding to the same subject. Immerse yourself in the group, share thoughts, gain new insights and ideas about techniques and approaches and see how others approach and interpret the same sessions as you.

Social media

Who needs conventional galleries? A digital strategy is an excellent way of reaching and attracting new supporters of your work. Social media enables you to display and market yourself. It is very easy to join in, make connections, find and gain followers and join the global community with a focus on your particular interests, life drawing and mobile digital art.

Build a following by uploading your work online. There are a wealth of platforms to choose from. Use your profile to reach unimaginable numbers of people. In August 2017 Instagram had 700 million active monthly users, Facebook 2.01 billion and Twitter 328 million. In addition, share and view images on Pinterest, an excellent social network where you can create boards around chosen themes, research, find links, follow and be followed. Flickr, an image- and video-hosting website with themed communities, can be worthwhile too.

Link your social media accounts to your own website and online shop. Use your social media posts to promote your work or any related activities on your site.

Presentation, online portfolio and sketchbook

Whichever app you work with, your images will be stored in the app gallery. This will be chronological. Your view of the gallery will depend on the app. It may be that you would prefer to have more control over organizing and displaying your work. Some of it may go towards a portfolio or a particular kind of presentation. How you store it may have a bearing on this. iPhotos will initially display your images as thumbnails and you can arrange them into albums as needed. As we have seen, your work can also be rearranged and placed into themed folders in Procreate. Organize your work depending on its requirements. Some work will be complete, some might be for research, development and future inspiration. Work left inside the app gallery is well placed should you need to continue working on it in time.

There are apps for organizing images such as Book Creator. Make an eBook to share and help promote yourself. A digital sketchbook is a convenient place for gathering information, perhaps to be used as the basis for oil painting. Understand your process by having the ability to access and easily review your work.

Printing options

Quality is all when making prints of your work. The crucial factors are colour reproduction, pixellation and scale. You want the colour in the print to be as close as possible to the digital original. Printed results can be remarkable but they will not have the back-lit glow of the iPad screen image. So some compromise in quality has to be expected. Colour can still sing and zing in the print though and the surface details can also be phenomenal at scale. This will depend on the pixellation.

Observe these points. Ensure to export well and produce the best-quality print possible from your original image. If your app gives you the choice, begin with the largest canvas size possible so you know the capacity for printing is there.

Printing

Create limited-edition prints from your images. Display and sell these online or mount, frame and exhibit them. The standard print process for iPad drawings is giclée printing.

A giclée print is a high-quality inkjet print recognized as being of fine-art quality. The print will have certain standard characteristics. It will be created at a resolution of at least 300 dpi for sharpness of image without fragmentation. The print paper will be of archival quality. This means it is acid-free and will have a 100% cotton or rag base ensuring quality colour reproduction. The prints should be produced on a large-format printer using pigment-based inks rather than a regular domestic inkjet printer which uses dye-based inks. The larger printers are able to print with many more inks than the standard printer, providing a greater range of subtle and saturated colours, which should maintain their quality for a significant amount of time.

Most quality printers will offer a giclée-printing service. Once the printer has your file you can in theory print-on-demand, making the process convenient. There may be an opportunity to set up the file with the printer and make some proof prints to check the colour balance and detail. Set-up costs should be fairly low. Print a limited run in advance or when required through orders.

Get prints of your work delivered to your doorstep by using a print-on-demand service. Online shopping is increasing in frequency day by day. Find new markets for your work and supply them cheaply and directly.

Framing and display

Framing is expensive. Rather than paying for a bespoke frame, standardize the size of your prints in order to take advantage of the ready-made sizes available for sale. Look for interiors stores or for online retailers.

Original prints

Can an iPad print be considered an original? In theory, a limited-edition numbered and signed print of an iPad image does, by default, constitute an original print. The actual image itself exists as a digital file only and the numbered prints are original in that they are the only recognized physical version of the image. They are not reproductions of an existing image that was created in another format. Some purists might have an issue with the notion that what has been produced is an original print. Their interpretation of this may be that an original print is an image that has been printed by hand, not reproduced from a photo or digital image, in a printmaking studio using an established artist's printmaking technique. These processes would include etching, aquatint, screenprint, monoprint, linocut, engraving and lithograph. It is a debateable point.

Sending images

You can send your images directly from the apps to a number of locations. The choice can be managed in the iPad settings. The options include email and message. You can also import directly to your iCloud drive and social media.

Brushes Redux has a limited choice. In Procreate and Adobe Sketch send your image to Photoshop. Export your file as a layered PSD to Dropbox or a similar cloud storage location. Adobe Sketch images can be sent to Creative Cloud in order to develop ideas further on a desktop computer.

DRAWBACKS OF THE IPAD

Drawing on the iPad will allow you to work in new and spontaneous ways unachievable in standard painting or drawing approaches. However, there are still a few drawbacks and it is important to mention them again. Scale is determined by the screen size. The maximum screen size for an iPad is, at the time of writing, the 12.9 inches of the iPad Pro. If you are used to working on a large scale this could seem small. Secondly, a painting or drawing made on the iPad has no tactile qualities, either on-screen as it is being made or subsequently when it has been printed. We cannot see the texture of an artwork or get a real sense of its construction in the way we can with an oil or acrylic painting. The tactile quality is an important part of the experience of viewing and appreciating art. Perhaps having the benefit of watching how we work in playback is a kind of compensation. The video playback is an insight into the creative process we cannot easily access with paint. The drawing then becomes a living, moving thing in itself; we see the story of its creation.

Despite these two examples, the iPad is an astounding tool that provides us with an incredible array of opportunities to make new images.

Conclusion

Who knows how people will be drawing in ten, twenty or thirty years' time. It is predictable that methods will change rapidly. Traditional approaches, pen, paper, paint and canvas will always be available and for some that will continue to be the best way. No one could have predicted ten years ago how the iPad would enable new mobile ways of recording, exploring and sharing visual ideas. The iPad, in its early days, was not really seen as a drawing tool. Steve Jobs never intended it to be used with a stylus. He did not see its potential as a drawing device. Now we can carry around a 12.9-inch sheet of glass in our hands like a piece of A4 paper that has within it as much potential as a full-size studio set-up. Some of its methods are unmatched in traditional painting and drawing techniques; they're unachievable. It begs the question: how can approaches to drawing and painting be extended and developed further? What are we going to be able to do next? What will the technology suggest to us and how will this enable us to respond to how we see the world?

Whatever happens, one struggle will remain: the struggle of seeing and getting down what has been seen, however we see it. In later life, Hokusai was still attuned to this endeavour.

I have drawn things since I was six. All that I made before the age of sixty-five is not worth counting. At seventy-three I began to understand the true construction of animals, plants, trees, birds, fishes, and insects. At ninety I will enter into the secret of things. At a hundred and ten, everything, every dot, every dash, will live.[36]
KATSUSHIKA HOKUSAI

Whatever the next stage is after the iPad, we will still be drawing and painting. We do it because we relish the encounter with reality and the difficult task of reflecting that. What can we do and how will we do it? This is the creative motivator. Don't let Hokusai put you off. Let him inspire you.

The Internet wasn't predicted, not even in science fiction, but it's a big, big thing. What's it going to obliterate? It will cause unbelievable destruction – and creation. One thing that is not being destroyed, though, is drawing. There are many handmade images in the digital world. For example, video games are drawn pictures. And a lot of them are rather good, actually. Now you can live in a virtual world if you want to, and perhaps that's where most people are going to finish up – in a world of pictures.[37]
DAVID HOCKNEY

NOTES

Introduction

1. David Hockney Exhibition Catalogue, Tate Britain (Tate Publishing, 2017, p.12). Quote taken from Gayford, M. and Hockney, D., *The History of Pictures: From the Cave to the Computer Screen* (Thames & Hudson, 2016)
2. Gill, A.A., 'All Will Be Revealed', *The Sunday Times Magazine* (December, 2012)
3. Marr, A., *A Short Book about Drawing* (Quadrille, 2013, p.126)
4. Franck, F., *The Zen of Seeing* (Random House, 1973)
5. Freud, L., 'Some Thoughts on Painting', *Encounter III*, no. 1 (July 1954)

Chapter 1: Essentials

6. Camp, J., *Paint: A Manual of Pictorial Thought and Practical Advice* (Dorling Kindersley, 1996, p.68)

Chapter 2: Measured Drawing

7. White, K., *101 Things to Learn in Art School*, (The Mit Press, 2011)
8. Dürer, A., *Human Proportions*, UT Health Science Center Library, http://library.uthscsa.edu/2012/03/albrecht-durers-human-proportions
9. Pearlstein, P., http://www.artistdaily.com/blogs/drawing/beyond-drawing-basics-philip-pearlsteins-unrelenting-gaze. Originally included in an ARTNews interview from 1962.
10. Petherbridge, D., *The Primacy of Drawing Histories and Theories of Practice* (Yale University Press, 2010)
11. Hambling, M., *Making Their Mark: Six Artists on Drawing* (BBC, 1990)

Chapter 3: Tone

12. Kemp, M., *Leonardo Da Vinci: The Marvellous Works of Nature and Man* (Oxford University Press, 2007)
13. Petherbridge, D., *The Primacy of Drawing Histories and Theories of Practice* (Yale University Press, 2010)
14. Kemp, M., *Leonardo Da Vinci: The Marvellous Works of Nature and Man* (Oxford University Press, 2007)

Chapter 5: Line

15. Rey, X. and Shackelford, T.M., *Degas and the Nude* (Thames & Hudson, 2011)
16. Gruau, R., Dior Illustrated: René Gruau and the Line of Beauty Exhibition leaflet (Somerset House, 2010)
17. Bridget Riley quoted in La Placa, J., 'London Calling', http://www.artnet.com/magazine/reviews/laplaca/laplaca7-21-03.asp

18. Hughes, R., *Goya* (Harvill Press, 2003, p.175)
19. Henri Matisse quoted in Flam, J.D., *Matisse on Art* (University of California Press, 1994)
20. Lubbock, T., 'Drawing is not an art, it's a cause', review of David Hockney, A Drawing Retrospective at the Royal Academy of Arts, (*The Independent*, 1995)

Chapter 6: Colour and Colour Contrast

21. Emile Nolde quoted in Ma, W., *Scene Design: Rendering and Media* (Hackett, 2012)
22. Albers, J., www.albersfoundation.org
23. Patrick Heron, Space in Colour, London Hanover Gallery, 1953. Gayford, M. and Wright, K. (eds), *The Penguin Book of Art Writing* (Penguin, 1998)
24. Blanc, C., *Grammar of the Visual Arts* (1867)

Chapter 7: Being Inspired

25. Camp, J., *Paint: A Manual of Pictorial Thought and Practical Advice* (Dorling Kindersley, 1996)
26. Anne Roquebert quoted in Rey, X. and Shackelford, T.M., *Degas and the Nude* (Thames & Hudson, 2011)
27. Neil MacGregor
28. Frank Auerbach quoted in Camp, J., *Paint: A Manual of Pictorial Thought and Practical Advice* (Dorling Kindersley, 1996)
29. Pearlstein, P., http://www.artistdaily.com/blogs/drawing/beyond-drawing-basics-philip-pearlsteins-unrelenting-gaze
30. Paul Valery quoted in Ferguson Gussow, S., *Architects Draw* (Princeton Architectural Press, 2008)
31. Henri Matisse quoted in Kannings, A., *Henri Matisse: His Words* (Lulu Press, 2014)
32. Ibid
33. Gelber, E., 'Vincent van Gogh: The Drawings', http://www.artcritical.com/2003/11/01/vincent-van-gogh-the-drawings
34. Lucien Freud interviewed by Martin Gayford, Rey, X. and Shackelford, T.M., *Degas and the Nude* (Thames & Hudson, 2011)
35. Halévy, D., *My Friend Degas* (Wesleyan University Press, 1964)

Conclusion

36. Katsushika Hokusai quoted in Gayford, M. and Wright, K. (eds), *The Penguin Book of Art Writing* (Penguin, 1998)
37. Gayford, M. and Hockney, D., *The History of Pictures: From the Cave to the Computer Screen* (Thames & Hudson, 2016)

achromatic colour – colour such as black, white and grey that has no hue

analogous – corresponding, similar

app – short for application. Usually a specialized downloadable program for mobile devices

Bluetooth – a wireless connection between devices such as tablets, mobile phones, computers and accessories

chiaroscuro – the distribution of light and dark in a painting or drawing

cloud storage – storing and accessing files from servers over the internet rather than directly from the computer, tablet or phone. Upload and access files from anywhere and then download. Convenient for working collaboratively, sharing files and backing up information and images

collage – a technique using a variety of materials pasted into the work

cross-reference – using one part of the drawing to check another

dpi – dots per inch

file format – file formats can store digital images in various ways, i.e., compressed, uncompressed or in vector formats

foreshortening – an object, such as the figure, that is not parallel to the picture plane will appear foreshortened. As it moves into space, the parts of the figure will appear shorter and compressed as it gives the illusion of recession or projection

glaze – a thin layer of transparent colour

iCloud – Apple cloud storage service

impasto – paint applied thickly onto the painting surface with the actions of application being visible

iOS – the operating system software used on the iPhone, iPod touch and iPad. iOS version 11 was introduced in September 2017

JPEG – 'Joint Photographic Experts Group'. A standard file format that compresses photographs in order to store, share and send across devices easily

latency – the time delay between stimulus and response

measured drawing – an accurate drawing made to scale

monochromatic – a painting or drawing using only one colour in a variety of shades

neutral ground – a coloured ground that is not a saturated colour but a mid-range grey or muted earth colour

observational drawing – drawing directly from the object

opaque – non-transparent

PDF – Portable Document Format. A file format that is used for viewing and generally not editing. It maintains its formatting from one device to another

Photoshop – a software program to digitally edit photographs

pictorial space – the illusion of space in a drawing or painting seemingly moving back from the picture plane, depicting distance

primary source – a source that is studied from first-hand experience. Observing a primary source allows for changing viewpoints, changing lighting conditions and close or distant viewing

process – the making of the painting or drawing; it can become a significant part of the work itself

proportion – the comparative relationship between the parts of the figure

PSD – an image file format used in Adobe Photoshop whose layers remain intact, allowing each layer to be worked upon individually after it has been saved

'push and pull' – the theory of push and pull was developed by Hans Hofmann. He proposed the idea that the illusion of space and depth in a painting can be suggested by the abstract use of colour and shape as opposed to the traditional representational approach of linear perspective

relief – a sculpture whose three-dimensional elements are raised from a flat base

secondary source – a source created by other people, such as a photograph, video, film, artefact or research found on the internet

TIFF – Tag Image File Format. A high-quality file format common for saving raster graphics images. They can be saved in a lossless or uncompressed format, thereby ensuring quality

topography – detailed mapping of the configuration and surface of an area

verdaccio – originally established by the Italian Renaissance painters, *verdaccio* is an underpainting technique that establishes the tonal values of a painting

FURTHER INFORMATION

iPad and App Compatibilities

Procreate version 4.0.4

Requires iOS 11.0 or later. Compatible with iPad Air, iPad Air Wi-Fi + Cellular, iPad mini 2, iPad mini 2 Wi-Fi + Cellular, iPad Air 2, iPad Air 2 Wi-Fi + Cellular, iPad mini 3, iPad mini 3 Wi-Fi + Cellular, iPad mini 4, iPad mini 4 Wi-Fi + Cellular, 12.9-inch iPad Pro, 12.9-inch iPad Pro Wi-Fi + Cellular, 9.7-inch iPad Pro, 9.7-inch iPad Pro Wi-Fi + Cellular, iPad Wi-Fi (5th generation), iPad Wi-Fi + Cellular (5th generation), 12.9-inch iPad Pro (2nd generation), 12.9-inch iPad Pro Wi-Fi + Cellular (2nd generation), 10.5-inch iPad Pro, and 10.5-inch iPad Pro Wi-Fi + Cellular.

Adobe Sketch version 4.4

Requires iOS 10.0 or later.

Auryn Ink version 2.0.17

Requires iOS 8.0 or later.

Brushes Redux version 3.2

Requires iOS 8.0 or later.

Websites

For further information and instruction on how to use the apps, go online and search for the app handbook or guide. In addition, look on YouTube for video tutorials.

https://www.apple.com/uk/ipad

https://procreate.art

http://www.adobe.com/uk/products/sketch.html

http://auryn.ink

Show, share, sell: online forums and digital communities

Saatchi Art (one of the largest online galleries in the world)

https://www.saatchiart.com

Behance (an online platform to showcase and discover creative work)

https://www.behance.net

Etsy

https://www.etsy.com

Fine Art America

https://fineartamerica.com

eBay (buy online from the world's largest community of independent artists)

https://www.ebay.com

Mobile Digital Art and Creativity Summit

http://www.mdacsummit.org

Digital exhibitions/prizes

Lumen Prize

https://lumenprize.com/

Life drawing and anatomy resources online

Croquis Cafe is a resource for artists. Find the videos on YouTube. Individual models take up poses for different amounts of time from one, two, three, four, five and fifteen minutes. Croquis 360 shows rotating views of the same pose in order to fully illustrate the pose from a number of angles.

https://www.youtube.com/user/onairvideo

https://www.posespace.com

http://www.posemaniacs.com

http://www.alienthink.com/pose-tool.html

https://line-of-action.com

Life drawing club

Sussex County Arts Club, Brighton

https://www.sussexcountyartsclub.co.uk

Most of the drawings in this book were made at Sussex County Arts Club. It is a life drawing club open to professional and amateur artists for life drawing/painting, costume, portrait, still life and sculpture. The club was established in 1944.

INDEX